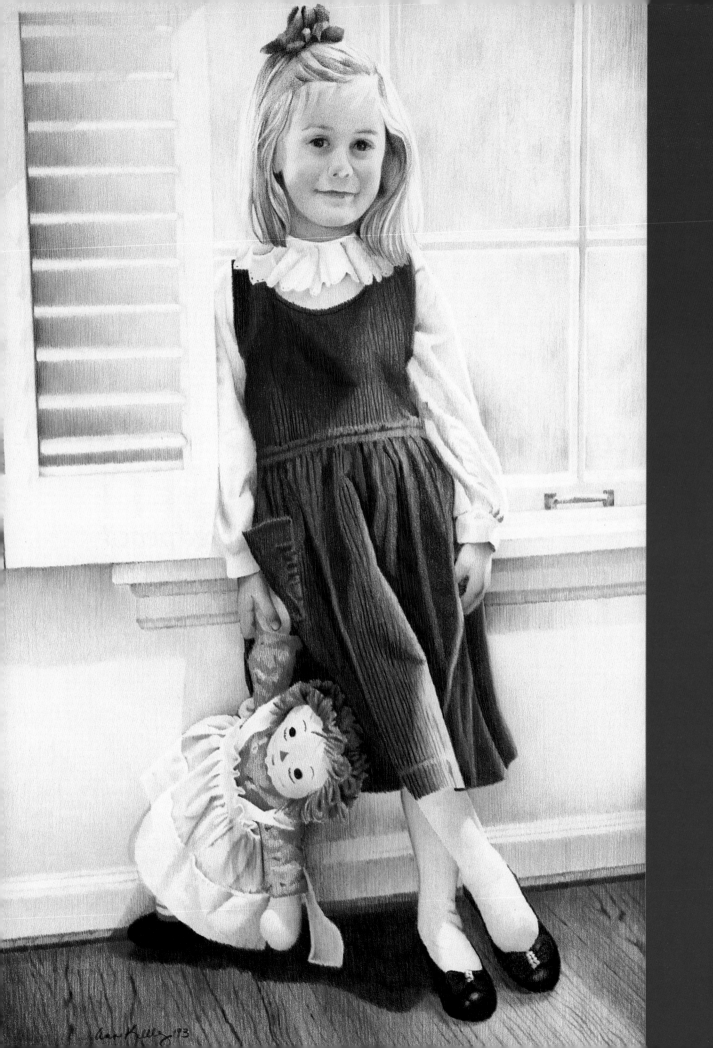

capturing
soft realism
in colored pencil

Ann Kullberg

NORTH LIGHT BOOKS
www.artistsnetwork.com
Cincinnati, Ohio

06 05 04 03 02 5 4 3 2 1

Library of Congress Cataloging in Publication Data
Kullberg, Ann,
 Capturing soft realism in colored pencil/ Ann Kullberg.— 1st ed.
 p. cm
 Includes index.
 ISBN 1-58180-169-6 (alk. paper)
 1. Colored pencil drawing—Technique. I. Title.

NC892 .K858 2002
741.2'4—dc21
 2001058990

Edited by James A. Markle
Interior designed by Lisa Buchanan
Cover designed by Clare Finney
Production art by Lisa Holstein
Production coordinated by John Peavler

Raggedy Ann and Me
20" x 16" (51cm x 41cm)
Collection of Sally and Peter Miller
Art from pages 2-3

About the Author

Ann Kullberg, a self-taught artist, first fell in love with colored pencil in 1987 and hasn't looked back since. For most of the last fifteen years, Ann has been a commissioned children's portrait artist, but she also teaches numerous workshops around the country, serves as juror for national art competitions, produces a line of colored pencil art instruction kits, and publishes her own online colored pencil magazine. Ann has also created a multimedia companion CD for this book, which can be found at her Web site at www.annkullberg.com.

Metric Conversion Chart

To convert	to	multiply by
Inches	Centimeters	2.54
Centimeters	Inches	0.4
Feet	Centimeters	30.5
Centimeters	Feet	0.03
Yards	Meters	0.9
Meters	Yards	1.1
Sq. Inches	Sq. Centimeters	6.45
Sq. Centimeters	Sq. Inches	0.16
Sq. Feet	Sq. Meters	0.09
Sq. Meters	Sq. Feet	10.8
Sq. Yards	Sq. Meters	0.8
Sq. Meters	Sq. Yards	1.2
Pounds	Kilograms	0.45
Kilograms	Pounds	2.2
Ounces	Grams	28.4
Grams	Ounces	0.04

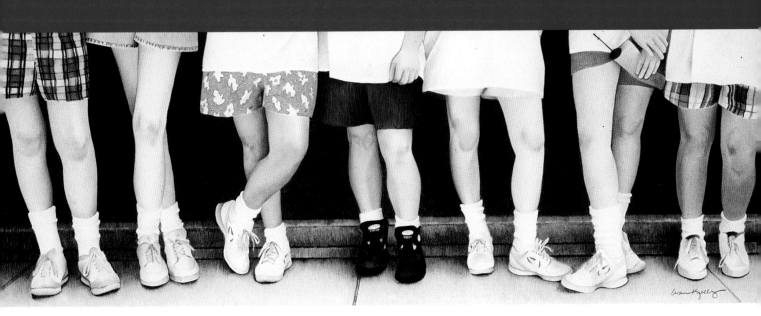

The Long and Short of It
12" x 19" (30cm x 48cm)
Private Collection

Dedication

To my sweetheart, Fayaz,
and to Kevin…my sunshine.

Acknowledgments

I would first like to thank my calm, positive, cheery, patient editor, Jamie Markle, who has been a real joy to work with. Thank you, Jamie, for all your help and support! I also want to thank Vera Curnow and the Colored Pencil Society of America. As do any of us who work extensively in colored pencil, I know that Vera and CPSA have made a world of difference in my life, and I am grateful always. And last, to my sweetie, Fayaz, for making my life easier, calmer and sweeter in every way while writing this book…and all without a single word of complaint…thank you. You're the best.

Table of Contents

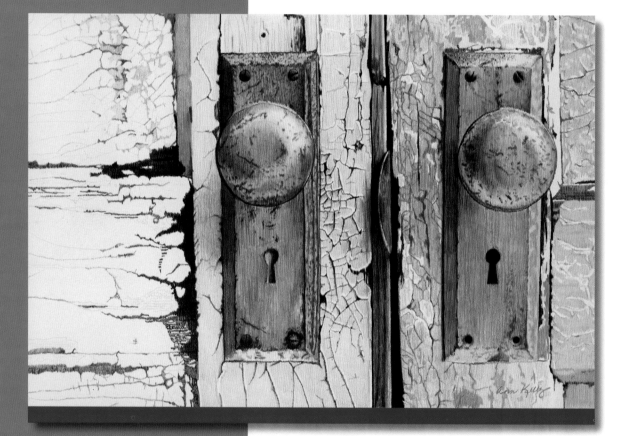

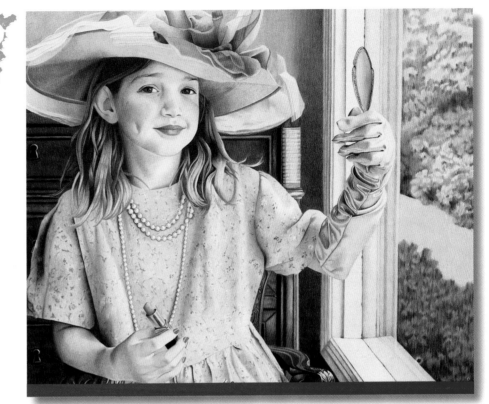

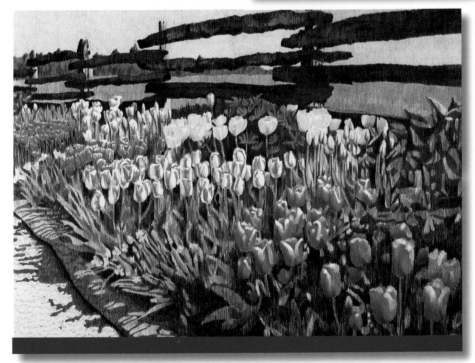

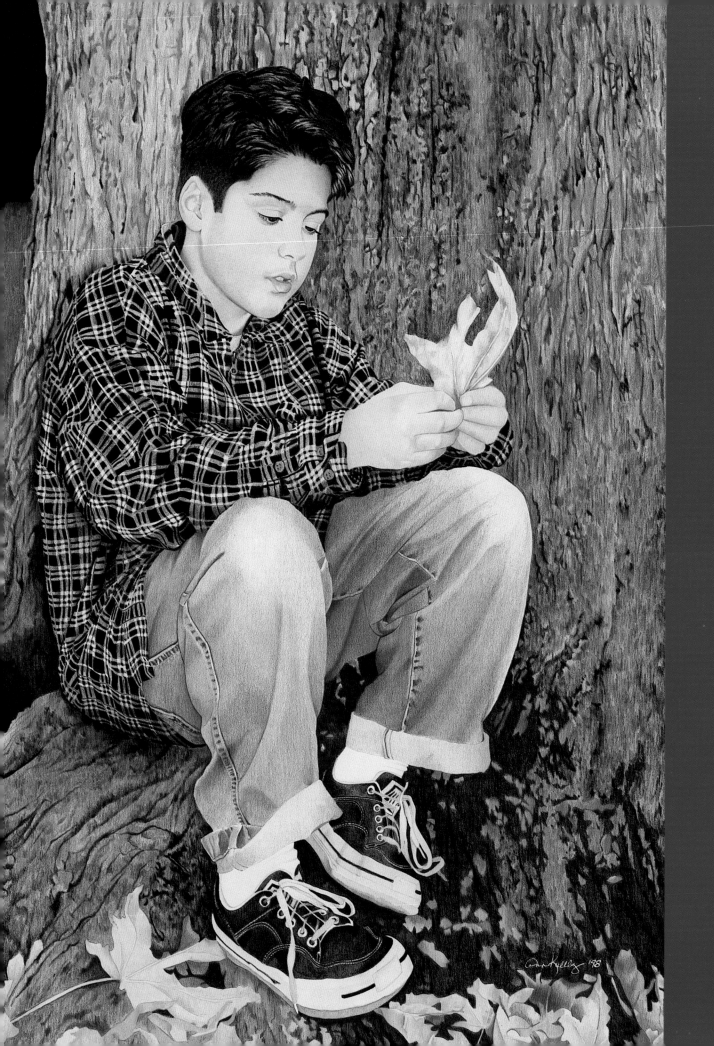

 # Introduction

Why write a book about a specific hedge here, a patch of grass there...a particular apple blossom and a striped couch? What are the odds you'll ever need to know how to draw my couch and pillows anyway? Slim, I'd guess! So why create a book full of individual, specific demonstrations?

When I started accepting children's portrait commissions so many years ago, it didn't initially occur to me that not only would I need to capture a likeness and paint believable skin tones, hair and fabric...but that I'd also need to paint foreground and background elements. One way around that, of course, would have been to paint the subject against a simple studio background of soft, painterly tones as a backdrop to the portrait. But I liked the idea of capturing a moment in a child's life that included elements of her environment—maybe her back patio, or a well-loved stuffed animal, or her favorite climbing tree. Consequently, over the last dozen years I've painted just about everything you can imagine into a portrait foreground or background...all kinds of flowers and greenery, beach scenes and waterfalls, streams, lakes and pools, baseball gloves, basketballs, toys and tractors, furniture of all types and textures, fall leaves and winter snow, cats, dogs, horses, bunnies and even a couple of boats!

Once I began teaching colored pencil portrait workshops, I noticed that students often had more trouble with the foreground and background elements than they did with the portrait subject itself.

And after my first book, Colored Pencil Portraits Step by Step *was published and I began offering my online colored pencil magazine, I realized that many readers had the idea that I paint background elements with the same careful, slow technique I use on skin tones and hair. And unless told differently, why wouldn't they? So the idea of this book came into being. I wanted to show you how I change my technique quite radically, depending on the subject matter, to speed things up a bit and to add texture and form without getting into too much detail.*

So, what can you learn from my drawings of a carpet or a pile of stones? Hopefully, how I work. What colors do I choose first? What pressure, what point, what sort of stroke? And more importantly, why do I make the choices I make? I very much hope that this is more than simply a "recipe" book. Instead I hope you find it a book full of explanations as to why I make the decisions I do. It was important to me, when writing Capturing Soft Realism in Colored Pencil *to let you know, as much as possible, why I choose certain colors, strokes and pressures. Hopefully, as you go through the demos and see how I paint my tulips with colored pencil, you'll gain knowledge, insight and techniques to help you paint yours!*

Taylor
26" x 20" (66cm x 51cm)
Collection of Rich and Leslie Begert

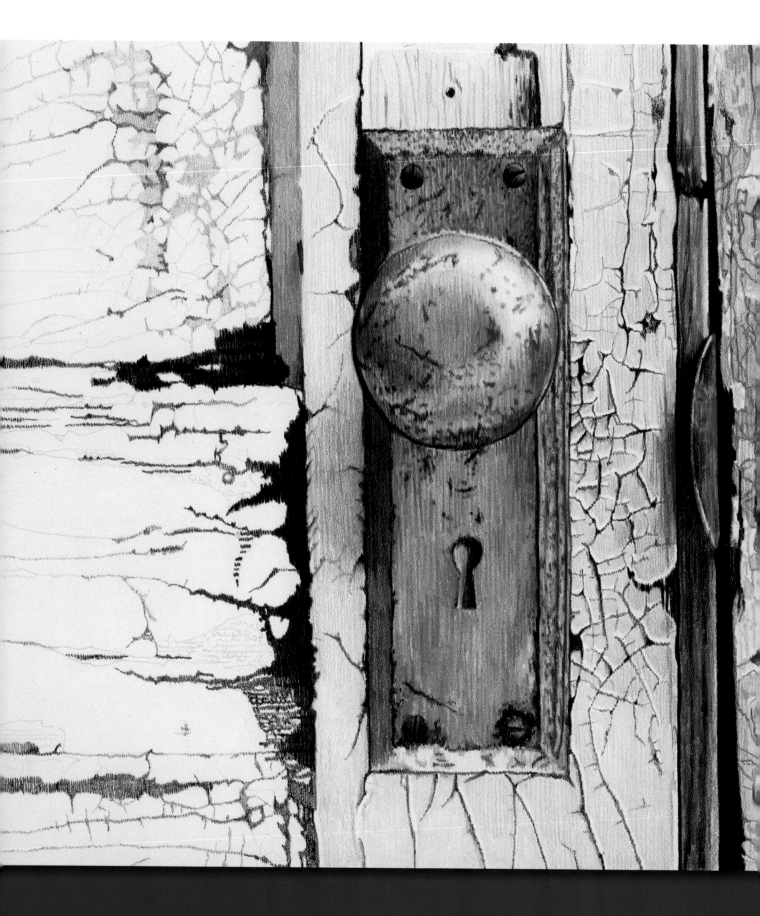

Getting Started

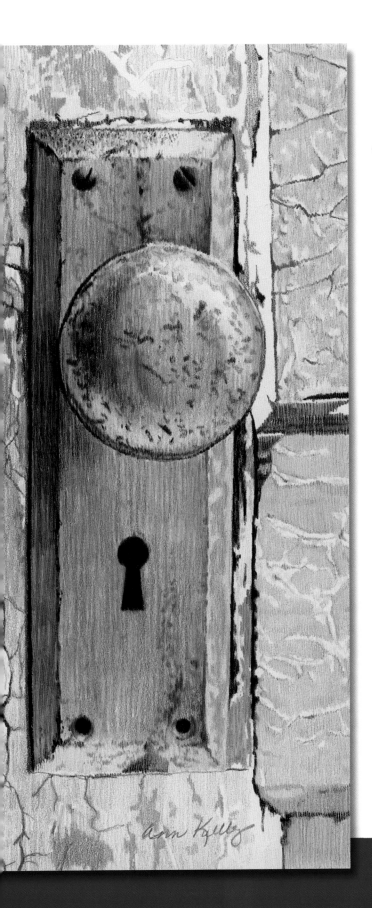

After my first book, Colored Pencil Portraits Step by Step, *was published, I began to teach many workshops around the country. I realized that most people assume that I create every aspect of my portraits with the same technique I use for skin tones and hair. And why would anyone think any differently…unless told differently? Which is why the idea for this second book came into being.*

My technique for building skin tones is to always use a very sharp point, a very light touch, and to build color slowly with numerous layers. But as you'll see in this section and throughout the book, my technique for various textures can be radically different from the slow, careful, precise building of skin tones. I often use a dull point and heavy pressure. I even occasionally use blending tools in order to render texture and speed up the already slow process of creating a colored pencil painting. I'd go nuts if I had to fill an entire 16" x 20" (41cm x 51cm) painting with only a tiny, sharp pencil point. So I came up with the following ways to hurry things up a bit without losing realism in the process!

Door Knobs
12" x 18" (30cm x 46cm)
Collection of Al and
Madeline Carow

Materials~The Basics

There are a hundred reasons why I love colored pencils, not the least of which is that you can get started without buying out the art supply store! Some relatively inexpensive pencils, paper, pencil sharpener and a few accessories and you're ready to go!

Pencils

For sixteen years I've been using Prismacolor (now manufactured by Sanford) colored pencils. I've tried a few other brands, but always come back to Prismacolor. They are inexpensive, lay down rich color and are widely distributed. It seems I've always been able to do what I want with Prismacolor, so I'm very happy with them. If you're just starting out,

buy a set of at least forty-eight, but preferably seventy-two. You can purchase any colors you would like that are not included in the set from open stock in most art stores.

Paper

Over the years, I've tried dozens of papers but settled on Stonehenge paper manufactured by Rising. Crestwood also distributes Stonehenge under their name. I guarantee you'll fall in love with this strong, clean and very inexpensive paper. It is wonderful!

There are very few decisions to make with Stonehenge as it only comes in one surface and one weight. All you need to select is the size and color. I use only plain white,

although it comes in several shades of white, off-white and cream. You can buy it by the sheet or in smaller pads of fifteen or so. It's a little hard to find if you don't have a well-stocked art supply store in your area, but it can be ordered from most of the larger art supply catalogs or Web sites. You'll know it's Stonehenge if your sheet has two deckle edges (the pads don't have any deckle edges.) Even with the large amount of layers and pressure I apply, this paper holds up beautifully and stays very clean (some papers really pick up the pencil grime and are hard to keep clean). You won't be sorry if you take the time to find Stonehenge.

Pencil Points
Different pencil points can produce different effects. A sharp point is great for detail work. A slightly dull point can be used for covering large amounts of paper with little detail. Blunt tips are great for burnishing.

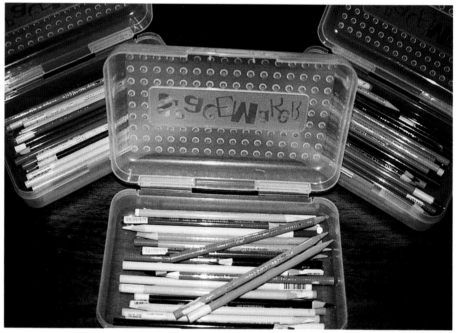

Organize Your Pencils
Most of the colored pencils I use are right here in these three boxes! Since I'm a portrait artist, I separate my pencils into one box for skin tone colors, one box for greys, blues and grey-like colors such as Greyed Lavender, and a third box that holds everything else.

Pencil Sharpeners

Let's face it, colored pencil is a slow medium! So I try to save time in whatever ways I can, and one way to save time is to use an electric pencil sharpener. To me, it is as essential as the pencils themselves! Handheld sharpeners take too much time, are messy and often chew up the pencils. Battery-operated sharpeners are fine for workshops where you don't want to worry about plugging them in, but they're slow and constantly need new batteries, so for the studio there's nothing like an electric sharpener. They're very inexpensive at large office supply stores, they're quick and offer a beautifully sharp point, provided you clean them often enough—we'll get to that later!

Every electric sharpener manufacturer will tell you on the box that the product is not intended for wax-based pencils, which of course, Prismacolor pencils are. Ignore that comment. All it means is that your sharpener will wear out a bit more quickly than it would if you were sharpening graphite pencils. My personal favorite is the Boston sharpener. Clean the parts frequently with a toothbrush soaked in solvent to extend the life of your sharpener; frequent cleaning will also make sure you empty the tray before it's completely full.

Drafting Brush

To keep your paper surface clean and your work from looking freckly, a brush is an absolute must. As you work with colored pencils, it is inevitable that bits of pencil dust will fall on your paper. Wiping the tip of your pencil with a cloth immediately after sharpening will help keep down the dust. Keep a rag directly under the sharpener, lay the pencil on the rag after sharpening and give it a twist. No matter how careful you are, however, pencil pigment particles will accumulate on your paper. If you don't brush them off, you'll eventually grind them into your paper either with your hand or with the pencil itself. Constant brushing is essential. I simply can't work without a brush, and would say that on average I brush roughly every two or three minutes.

Paper, Pencil Sharpener and Drafting Brush
Other than the pencils themselves, these items are all you really need to get started on your colored pencil art!

Materials~Accessories

You can certainly use colored pencils without any of the following tools, but they're awfully nice to have and can really come in handy. You could add an electric eraser to this list, too. I don't use one, but I've seen them used by other colored pencil artists to create some interesting textures by erasing layers of pencil.

Sticky Stuff—Reusable Adhesive

I don't know what I'd do without my *sticky stuff*—reusable adhesive—it's definitely one of my favorite tools! (I keep a blob on top of my sharpener so I always know where it is.) What do I do with my blob of reusable adhesive? For starters, I put a tiny bit on the four corners of the back of my paper so my work will stay on my tilted drafting table. The effect is similar to Velcro® in that you can easily lift the paper off your drawing surface and easily stick it back on.

I also have a nickel-sized blob that holds my drafting brush permanently stuck on the right side of my drafting table. Before the blob, it seemed I was constantly looking for my brush. I'm willing to guess that the sticky stuff that holds my brush saves me close to an hour per portrait just in brush-searching time! Finally, sticky stuff is a great eraser or lifter. No matter how often you brush your piece, you'll still get pencil grime on your paper. Simply rolling a blob over those areas will completely clean that up. It also works much better than a kneaded eraser when you want to lift pencil off your work. I use Handi-Tak® reusable adhesive, found at most office supply stores, but there are many different brands and they all work just fine. I would stay away from mounting putty, though; I don't think it's tacky enough.

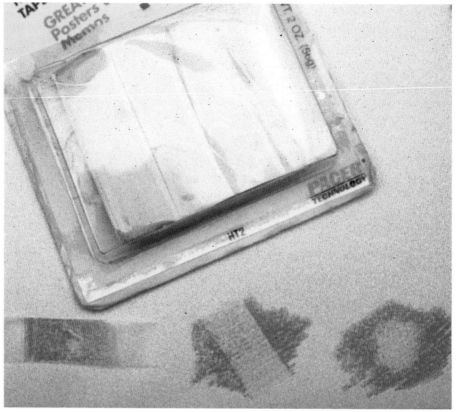

Sticky Stuff

Here is one of a half-dozen or so available brands of reusable adhesive—sticky stuff. Among other things, sticky stuff is great for lifting colored pencil. The swatch on the right has been lifted with a blob of sticky stuff. The swatch on the left has been lifted with the piece of invisible tape shown on the far left.

Pencil Extenders

It's very tough to control your stroke when using a short pencil. Since colored pencil is one of the most controlled art mediums available, chances are you've chosen colored pencil because you like control and don't want to lose it! Using a pencil extender is one way to maintain control. They are available at larger art supply stores, and while a bit expensive, they're worth the cost for the control you retain. I own about a dozen, but you really only need to invest in one.

Eventually, the pencil gets so short that it no longer fits into the pencil sharpener. So now what? If you're frugal like me, you will want to use as much of the pencil as you can, so try this: Take a stub and a new pencil of the same color, and using a bit of super glue, stick the two together. This allows you to use nearly the entire pencil!

Q & A

Q: Why do you sharpen both ends of a glued pencil?

A: Some people only sharpen one end of a glued pencil, so they can sharpen all the way through the stub and not waste even a tiny bit of the pencil. But I really love having two sharpened ends at my fingertips, so I sacrifice that little bit of pencil stub for the benefit of needing to sharpen less often.

Pencil Extenders

A short pencil is hard to control, but you can't just throw them away when they get too short! Here are two options: a pencil extender, which you can buy at art or graphic supply stores, or use super glue to affix a stub to a new pencil of the same color.

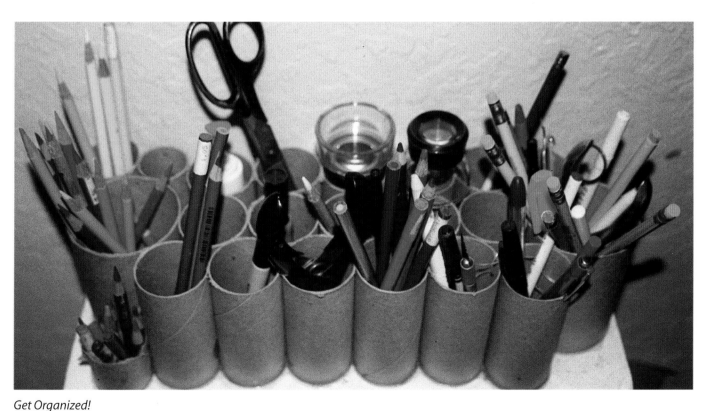

Get Organized!

I made this pencil holder using a piece of foamcore for the base and toilet tissue rolls. The rolls are glued onto the foamcore. It holds pencils, pencil stubs, pens, markers, scissors, photo loupes, hole punches, craft knives—anything you need to keep at your finger tips. This is a great way to stay organized!

Mylar Film

Although not a tool strictly related to colored pencil, I've found this to be a must-have in my studio. With properties similar to tracing paper, it's a fabulous tool for transferring drawings and more, because it is far more transparent than tracing paper. I use a 3mm sheet that is rough on one side and smooth on the other. And what do I do with it?

Tracing

When you want to trace directly from a photograph, throw away your tracing paper! Use Mylar film instead because it is far more transparent and you'll get a much more accurate tracing. Lay a sheet of Mylar film over your photo with the shiny side down and the rough side facing up. Trace your photo onto the Mylar film using a regular no. 2 graphite pencil. To get your tracing transferred onto your paper, lay the Mylar film with the sketch onto a light table or attach it (using tiny bits of sticky stuff) to a window. Now lay your paper over the Mylar film. You'll be able to see your sketch lines right through the Stonehenge. Trace those lines using a no. 2 graphite pencil. Make sure you use a very light touch when tracing or you'll accidentally impress or score the paper. These impressed lines are virtually impossible to get rid of, so make sure to trace with a very light pressure!

Color/Value Choices

When you're unsure as to how to proceed in a painting, there's nothing like Mylar film to allow you to try different options without commitment. Lay a sheet over your partially finished drawing, then work directly on the Mylar film to try different colors or darken values. Mylar film will only take a few layers of colored pencil before its surface tooth fills up, but it does afford you a glimpse of what an area on your painting might look like without actually having to work on your piece directly.

Drawing Practice

Ever had a section of your painting where the drawing isn't quite right? Maybe a portion of a hand is cropped off your photo, but you want to include it in your painting and you're having trouble with the drawing, or maybe you want to add eyelashes to your nearly completed portrait and you're worried about ruining the whole piece with some badly drawn lashes. Mylar film allows you to practice these difficult areas over and over until you're ready to proceed with your painting. Just lay a sheet over your painting, then use a graphite pencil on the rough side to practice your drawing. Pencil (and colored pencil) erases easily off Mylar film, so you can practice as often as you need to. When you're happy with what you've done on Mylar film, you can draw directly onto your paper.

Q & A

Q: Even with Mylar film, I sometimes can't see the darker areas of a photo when tracing. What should I do?

A: Always trace a photo over a light box or with the photo attached to a window (during daylight hours). You'll be able to see much better in the darker areas of the photo and you'll get a much more accurate tracing.

Mylar Film

The left side of this photograph is covered with a sheet of tracing paper; the right is covered with a sheet of Mylar film. Although the difference may not look terribly dramatic here, when you're tracing, every little bit helps! The Mylar film side is less diffused, which makes it much easier to trace through. Having tried Mylar film, I would never again use tracing paper.

Loupes

A loupe is a magnifier commonly used by watchmakers and photographers. They can be found in art supply and drafting supply stores. The loupe is very handy when you can't quite see detail in your photo reference and you need it magnified. Some also come with a handy slide attachment so you can magnify your slides. Although I don't use mine too often, it's a lifesaver when I really need to see something enlarged. Here's a hint: Hold your photo up to a light bulb and look through your loupe. It's amazing how much you can see! It's very much like getting a huge, overexposed photo, which at times is exactly what you need!

Drafting Table or Drawing Board

While not necessary, a drafting table or drawing board is a very useful item. Working flat tends to distort your vision. If you're working on a relatively large piece on a flat surface, you simply will not see what's at the top of that piece without distortion. Working flat is also hard on your back!

If you don't have the room or the pocketbook for a drafting table, invest in a Masonite drawing board from your local art store. Or, at the very least, buy a piece of foamcore and have your framer cut you a piece of Plexiglas to fit the foamcore. Place the Plexiglas over the foamcore, and tape the edges. Now, roll up a big bath towel (and tape around it so it stays rolled, if you like) and place the rolled towel under the top of your board. This will give you a cheap, light, hard adjustable tilted surface to work on!

Plexiglas
One piece of Plexiglas, one sheet of foamcore cut to fit, a little tape, a rolled-up towel and you've got a lightweight, portable, sturdy, tilted drawing surface!

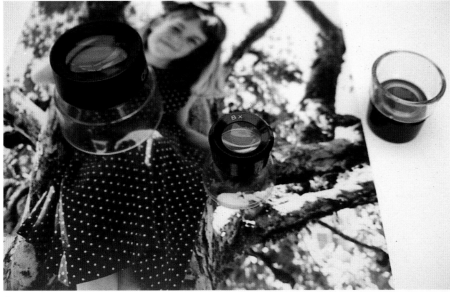

Loupes
Here are three loupes in different sizes and strengths—they all come in handy. The large one is great if you're working flat, as you can lay it over your photo reference and leave it there. I've also been known to attach a slide to a loupe by placing tiny bits of sticky stuff to the outer edges of the loupe and sticking a slide directly to the large open end.

Value Viewer

This isn't a conventional tool since you won't find it in an art supply store; however, it is by far my favorite tool and one I simply cannot paint without! I call it a value viewer and it is simply a hole punched into a rectangle of white paper. I place it over my photo reference to help me determine both value and color. Isolating a small area helps unbelievably in this aspect to really see without the distraction of surrounding colors and values. Areas that I thought might be in the midtone value area, once isolated, often turn out to be quite a bit darker than I thought originally. I also use the viewer for choosing colors. How? By isolating an area, then asking myself a series of questions. What color do I see in the little round hole? Green? What sort of green? Yellow-green? Blue-green? Grey-green? Say it's blue-green, then I ask, how dark or light is it? What sort of blue should I add to the green? A gray-blue? Bright blue? You simply must try this little trick, because surrounding a color with white suddenly makes answering these questions much easier!

Say you're trying to match colors in a photo reference. Use this twist on the original value viewer to help. Take a leftover strip of your drawing paper, and punch numerous holes in it. Next lay Mylar film over the hole-punched paper. Lay one of the holes over the photo, and draw directly on the Mylar-covered value viewer made from your drawing surface. Now you can build color until your paper matches what you're seeing in the hole!

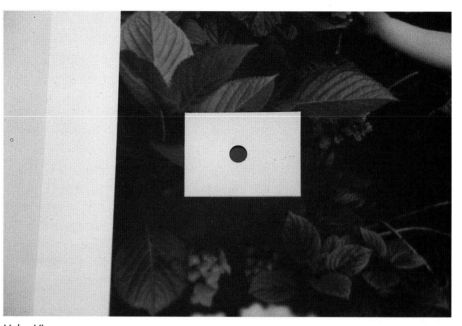

Value Viewers
Using the value viewer to isolate a tiny portion of two different hydrangea leaves in this photo helps me to see the difference in color and value, and helps me choose a palette for building the color in each of these leaves.

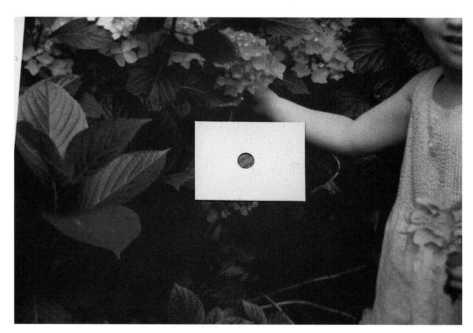

Vertical Line~Smooth Stroke

You've got all your supplies—now you're ready to get started! One of the most wonderful things about colored pencil is its newness in the fine art arena. It's so new to the art world that each of us using colored pencil is wide open to explore techniques and find our own voice. Over the years, I've developed my own techniques for rendering various textures and objects that save time without losing the realistic quality I'm always after. And you might be surprised to see it's not as hard as it looks!

Years ago, I realized that I simply didn't have the patience to work in colored pencil. At least I knew I didn't want to continue to paint in the way I was working at the time. I was scumbling, which amounts to a very, very tiny circular stroke that takes hours and hours to cover large areas. The advantage to scumbling is that you have almost perfect control, and you can create the finest of gradations in color and value. But boy, does it take time and patience! I developed my vertical line technique in desperation to speed up the colored pencil process. This technique radically cuts down the time it takes to complete a colored pencil painting and with slight modifications is very adaptable for rendering any number of different textures and surfaces.

My vertical line technique is just a group of individual vertical lines placed very, very close to one another. It's really as simple as that! My strokes are generally under an inch (2.5cm) long, although this varies depending on the space I'm working in; smaller spaces may require a shorter stroke. I try to vary the stroke length slightly to avoid a horizontal row look. Each stroke is so close to the next that they are practically on top of each other. In other words, there is no paper showing between the strokes.

Glossary

Use these basic terms to help you complete the demonstrations in this book.

Burnishing—using so much pressure that you smooth out the paper surface

Wash—a flat, even tonal application of color with no difference in value

Modeling—increasing or decreasing value to suggest form and depth

Directional stroke—a stroke that follows the direction of the form

Road-mapping—filling in dark areas in a complicated pattern or texture so you can more easily see where you are

Airy—using a dull pencil or a loose stroke so lots of paper surface shows through

Dense—using a sharp pencil and a tight stroke so most of the paper surface is covered and very little paper surface shows through

Take-down—to dull down, usually by adding some sort of grey

Dull—greyish colors with no brightness or intensity (Clay Rose is a good example)

Bright—colors that are more raw, more intense (Pale Vermilion is a good example)

Value—lightness or darkness. A dark pencil could still have a light value if applied with very light pressure.

A

B

Vertical Line Technique—Smooth Stroke
Applied with a light touch and a very sharp point, the smooth vertical line technique creates an even tone, like a watercolor wash. Example A shows how close my strokes are—they really are practically on top of each other. In example B, I've placed them widely apart so you can see how fine each line actually is.

Pressure Bar

When I'm going for a smooth look, I use a very sharp point and a very light touch. How light a touch? I use a scale from 0 to 5 to express the pressure. A 0 is what I call a whisper—just barely touching the paper. A 5 is a scream—pushing as hard as I can until the surface of the paper is flattened by the pressure of the pencil. Most of the time when I'm trying to achieve a smooth, even texture, I use about a 1 or 1.5 pressure. It takes a while to become consistent with this light of a touch, but it's easier if you hold the pencil loosely in your hand. The more firmly you grip the pencil, the more difficult it is to apply lightly. A word of caution: Do not give in to the temptation to hold the pencil far back in the shaft (far from the point). Although this makes it easier to apply light pressure, it causes other problems. For now, just hold your pencil how you naturally hold a pencil when you write.

Keeping your pencil sharp is also very important for this smooth stroke. Either roll the pencil in your hand while working or turn it very frequently. This will help keep your point sharp and will also allow you to work a little longer between sharpening.

Q & A

Q: How do I know if I'm using the right pressure?

A: Consult the pressure bar; it may help you gauge your pressure. Most people write in the 2.5 to 3 range. Try making a small pressure bar yourself to gauge what a 1 feels like compared to a 3 or 4. Then try writing normally (not drawing) and see where your natural pressure lies in the range from 0 to 5.

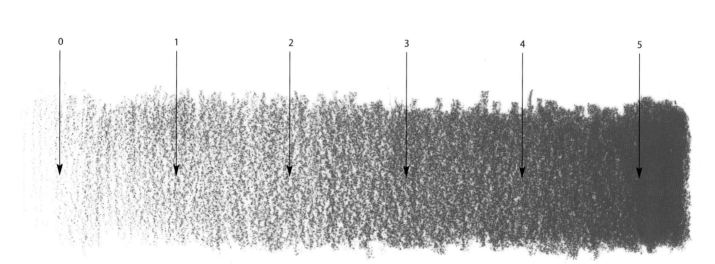

0 to 5 Pressure Bar

This bar shows the pencil pressure range from 0 to 5. The far left is a whisper and the far right is a scream. You're not screaming unless you see absolutely no paper showing through at all. This is technically called burnishing. I rarely burnish except when painting shiny, smooth surfaces like glass or polished metal.

Feather vs. Definite Stroke

A light touch and a sharp point help to create a smooth, even application, but there's one more trick. Rather than starting and ending each stroke with a definite pressure, I descend and lift-off with each stroke. This creates a feathered, very light area at the top and bottom of each stroke so they blend easily with the strokes above and below them. This avoids the overlapping that occurs with a quick vertical line stroke. (See page 22).

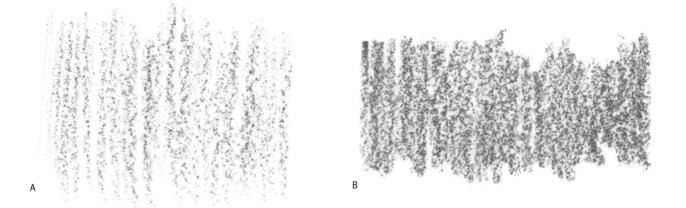

A B

Feather vs. Definite Stroke
The strokes in example A are feathered at the top and bottom so they'll blend easily with a group of strokes above or below them. The strokes in example B have a definite start and stop with no feathering on either end. The definite strokes are darker because it's nearly impossible to use a very light pressure with this stroke!

C

D

Choppy Stroke
The strokes in example D are too short if you're trying to achieve a smooth look. They may be the perfect length, however, for grass or woven textures as seen in example C.

Vertical Line~Quick

While the smooth vertical line stroke (page 19) works well for areas that require an even application of color, it can still be a trifle on the slow side when covering large areas. If I'm filling a large space, and it's not an area that requires a smooth look, I modify the vertical line stroke slightly to speed things up. The only real difference is in the start and finish of each stroke. I don't feather the top and bottom of each line; being less exact, it goes a little faster. I still lift the pencil after each stroke and vary my stroke length slightly, but because I don't have to pay as much attention to the start of each stroke it moves things along more quickly.

Q & A

Q: How do I know if my pencil strokes are the right length?

A: If you're trying to cover an area with a flat, even coat and it looks choppy, your strokes are probably too short. If you're having trouble keeping your lines straight and they're curving slightly, your strokes are probably too long. The stroke length should feel natural to you.

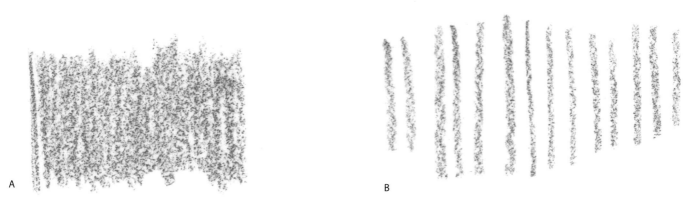

A B

Vertical Line Technique—Quick
Not having to worry about feathering the top and bottom of each stroke saves time so this technique goes more quickly than when trying to create a smooth look (example A). You can also get away with a point that is slightly dull so more paper is covered with each stroke. Example B shows how much thicker each stroke is (because of a duller point) than with the smooth technique.

Overlap and Straddle Strokes

With this faster stroke, you'll get an overlap as the top of one stroke goes over the previous stroke. To avoid getting too much of an overlap effect, I straddle the overlap in subsequent layers by starting my stroke mid-way through the previous layer. If I start my strokes on each subsequent layer in the exact same place I started them on the first layer, eventually I'd get a very distracting overlap pattern. As you build layer upon layer, straddling the overlap will create so many different overlap areas that it will read as a texture instead of pattern. In areas where you don't want any overlap, use the smooth vertical line technique. But in areas where a little texture or a little movement would be a plus, you should try the quick vertical line stroke.

Overlap Stroke
The darker spots are overlapped areas where the top of one stroke covers the bottom of the stroke above it. If I started each successive layer's strokes in the same spot as the first layer's, I'd eventually get very dark overlap areas that could be quite distracting.

Straddle Stroke
With the second layer, I straddle the overlap strokes by starting each stroke halfway between the first layer's strokes. This combats the distracting look of the overlap stroke.

Scribble Stroke

This stroke is so fast, we're practically ready for the autobahn! Although very similar to my quick vertical line stroke, this one is even faster since you don't lift your pencil with each new stroke. In other words, the vertical lines are all connected, and you're applying pencil with both the downstroke and the upstroke. Even though the difference in technique is very slight, it makes a difference in the look. For one thing, you're more likely to get what I call *freckles* with this stroke, so you'll want to reserve it for areas that will have a lot of texture where freckles won't be noticeable.

So what's a freckle? It's a very tiny patch of darker color in the middle of your stroke.

When teaching workshops, I often hear people complain that their layers look rough. On close examination, I'll see that their work is full of these little freckles. (Freckles are so tiny that it's virtually impossible to show here, but you'll know one when you see it.) It took me forever to figure out why some people get lots of freckles in their work while I get very few, but I finally discovered the cause. A freckle is a teeny fragment of pencil grime that falls off the tip of your pencil. When you go over that tiny particle with your pencil, it flattens out and it becomes embedded in your layer. How do you avoid freckles? First, as soon as you're done sharpening your pencil, wipe the tip to

remove any stray fragments that might fall onto your paper. Second, use your drafting brush like a maniac! I use my brush so often that a student once told me that when she first saw me demo she thought my brushing was a nervous tic! Keeping the surface free of any and all stray fragments will keep your work freckle free. With the scribble stroke, though, you're moving quickly, so the pencil grime that grinds off your pencil point will probably be immediately flattened on your next upstroke. Save this stroke for areas where a rough look is a plus, not a problem!

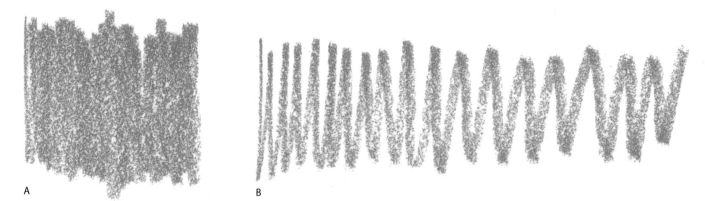

A

B

Scribble Stroke

My quickest technique, the scribble stroke (example A), goes quickly because you don't lift your pencil after each stroke. In other words, it's one long connected stroke, like a zigzag that's very close together. Example B shows you how the strokes are connected. I never actually use strokes this far apart! It's harder to press lightly with this stroke, so save this technique for quick, dark underlayers or for areas that are rougher in texture. This grinds your pencil down quickly, which means lots of bits of pencil grime, so be sure to stop frequently to brush!

Broken Scribble Stroke

There are times, when adding texture, that I need to break the scribble stroke up a bit. The main idea with this stroke is to break up the line randomly: Vary the length of your broken line, vary the width of the line and vary the space between. If there isn't enough variation, your stroke will end up looking like small, choppy lines instead of the texture you're trying to achieve. Although this stroke moves all around the paper, keep it connected by not lifting your pencil as you move around.

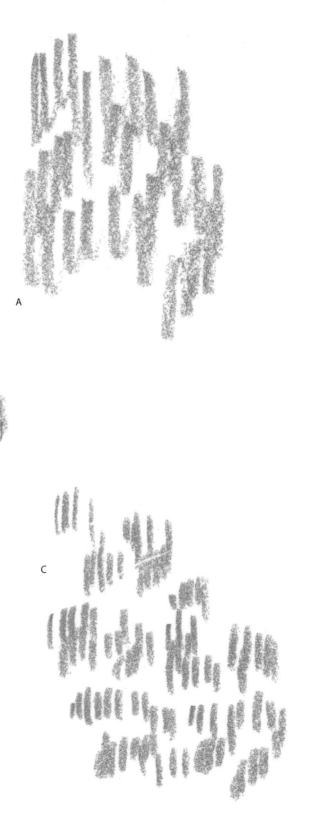

A

B

C

Broken Scribble Stroke

This stroke is perfect for creating all kinds of rough texture or painting with a looser touch. Keep the strokes somewhat connected by never quite lifting the pencil off the paper. The longer strokes in example A may be just right for tree bark or loose foliage in the background area of a painting. The shorter strokes of example B are just right for lawn, loose bushes and hedges. Example C is not a loose scribble stroke at all but very short vertical lines. This looks even choppier, so I rarely find a use for this sort of stroke.

Dense vs. Airy

I can control whether an area looks dense or airy by changing the amount of paper that shows through the layers of colored pencil. Some textures need a certain visual weight or density to look right. In these areas, I make sure that most of the paper surface is covered. To do that, I use a very sharp point. A sharp point will get into most of the "valleys" of the paper surface, covering most of the paper to create a dense, thoroughly covered area. For instance, a wood floor should look fairly solid, so I'd want to make sure that all the hills and valleys of the paper are covered, and the only way to do that (aside from burnishing) is to use a sharp point. Other textures like tulle, clouds or lace could use a more airy appearance. For those, I might use a very dull point, which would let lots of paper show producing a less weighty appearance.

Q & A

Q: I'm trying to create a light, airy quality but every once in a while I get a darker line, even though I'm sure I haven't increased my pressure. What am I doing wrong?

A: If you haven't increased your pressure but you suddenly get a darker line, I'm guessing it's either because you've just sharpened your pencil or you've turned it. Once you sharpen (or turn) a dull point, it immediately gets into more valleys, so with less paper showing, it looks darker.

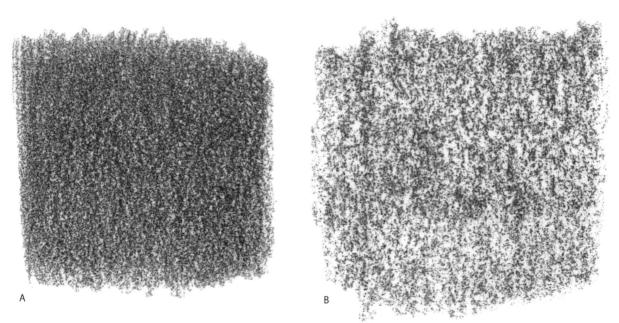

A B

Dense vs. Airy
Using the same pressure for both examples, I've varied the density of the layer by using a very sharp point (which I turned often to keep it sharp) in example A and a very dull point in example B. A dull pencil simply can't fit into as many of the valleys of the paper. This means fewer valleys are covered with pencil, so by default more of the paper surface shows through.

Where to Start~The Painting Sequence

I've been on the road teaching workshops for years now, and the number one problem I see over and over again is students working on paintings in a sequence that eventually works against their intentions. Starting the work by first painting the thing you're most attracted to is rarely a good idea. Instead, working dark to light will save you hours of time and indecision.

1. If your white paper is your lightest light, getting in your darkest value first will make it easier for you to determine the mid-range values. How can you paint mid-tones without establishing your lightest light and darkest dark? There is no way you can possibly know what's in the middle.

2. You're painting a yellow tulip against a dark green background and you start by painting the tulip. After all, that's the fun part and it's what you are really excited about doing! You finish your tulip and it looks lovely and you're pleased. Now you fill in the dark green background. Guess what? I'll bet your tulip is now too light and too pale, and you'll have to go over the whole thing again. Working on that yellow tulip surrounded by white paper, you naturally underestimated the value, because anything looks darker next to white. I don't know about you, but I can't stand going over an area again that I'd previously considered finished!

3. Say you don't listen to me and start with the yellow tulip anyway. The tulip takes you four hours to complete. The large green background is going to take you fourteen hours. You now have the rather daunting task of keeping that tulip clean for the next fourteen hours. If you're like me, it isn't going to happen! As often as I brush and as careful as I am, I just can't keep areas clean of the little tiny pencil fragments that fall onto the paper as I work. The only solution is to clean the tulip, which means lifting the spots with sticky stuff. Lifting is great, but it's hardly an exact science and you never really lift just what you want without lifting neighboring areas. So now you have to go over your perfect

tulip where you've lifted more than you wanted. Personally, I'd much rather put in the fourteen hours doing the dark background first. Then right before working on the tulip, I clean the tulip area by rolling sticky stuff over it, and I only have to keep that area clean for the next four hours while working on the tulip!

4. The last reason for getting my darks in first is an easy one to understand for most artists. Do you eat the frosting before the cake? If you do, do you really want the cake? Once

the frosting is gone, do you sort of feel like, "What's the point?" Isn't the tulip the frosting? Do you really want to draw that background now the frosting is gone? Neither do I! If I get the drudgery out of the way, I'm still excited about the piece all the way through to the end. Flip the sequence, and I'm just not excited about the piece anymore. I would much rather start a new painting with a new pretty flower!

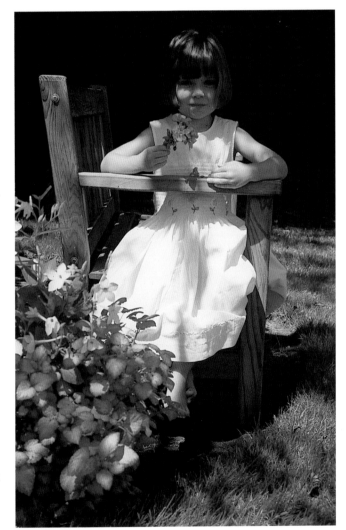

Work Dark to Light
I'd start with the darks on this piece, as I do with every piece. The painting sequence from first to last would be as follows: dark background, lawn, bush, wood furniture, hair, magenta flower, arms and legs, face and dress.

Building Color

Building color is, in a nutshell, a matter of starting light, using your value viewer and asking yourself, "What color do I see now, and how light/dark is it?" This may seem a bit confusing after telling you I start with the darkest areas, but my second rule is to start, in any given area, with the lightest color I see.

Let's use this little guy's shirt as an example. I first look at the shirt using a value viewer to find the lightest area and then ask myself what the lightest color is. I think the lightest color here is Blue Slate, so I first wash his entire shirt with that color, using a light pressure. I want to make sure I leave plenty of paper tooth since I don't know how many layers I may be applying in order to get the color I want.

Next, using the value viewer, I ask myself what the next lightest color is. If I'm not sure what color it is, my next question is what color is it? If it's blue, what sort of blue is it? Is it greyish? Purplish? Greenish? Once I've narrowed down the color, it's easier to choose the right pencil. Since the blue of this shirt leans toward the purple side, I might choose Blue Violet Lake and cover all but the lightest areas using a light touch of a 1.5 to 2 pressure.

At this point, I might go in and establish the darkest darks of the shirt to establish the midtones. Again, I start with the lightest light. I place the value viewer over the lightest spot in the darkest area of his shirt, then determine what sort of blue I see. Let's say it's Mediterranean Blue. I'd wash all the shadowed areas with Mediterranean Blue, using a 2 to 3 pressure. I can use a heavier pressure here than in the lighter areas, because I know I won't be using that many layers to completion because I'm starting with a relatively dark-valued pencil. Over the Mediterranean Blue I'd layer the next lightest color I see, which might be French Grey 70%. In this case, I'd use the French Grey 70% over the entire shadowed area, right over the Mediterranean Blue.

Why not leave some areas with just the Mediterranean Blue? This area is very dark and needs to be quite dense. A lone layer of Mediterranean Blue would be too airy and too light for this dark area. It would also be too raw, lacking a richness and blend of color. One layer of colored pencil is rarely enough to create a realistic look except in the very lightest areas and the most delicate of textures. I'd continue to build the dark area of the shirt by placing the value viewer over the photo reference and asking, "What color and value do I see?" Once the darks were completed, I'd go to the light and midtones to build them up by choosing progressively darker colors, and leaving more and more areas alone. In the end, the lightest highlights of the shirt may have just two layers, the midtones may have as many as six to eight, and the darkest shadowed areas may have four or five layers.

What Color is "Blue"?

Look at the shirt in this photograph. What color is it? Blue? When using colored pencils, the answer is rarely that easy. Often many different pencils are needed to recreate what you see in your photo. Use your value viewer to isolate the colors and find pencils that match.

Value

I've said a lot about the importance of value, and about using the value viewer, so I need a word here about the values found in my photo references and how they compare to the values found in my paintings. Generally speaking, my darkest values are as dark or nearly as dark as the darks in the photograph. My lightest values are generally lighter than the lights in the photograph. To put it simply, my darks are as dark but my lights are lighter than in the photograph. This gives the painting more drama and more punch than the photograph, and also allows me a broader range for my midtone values. By and large, my midtones are also somewhat lighter than in the photograph.

My last word before launching into the fun stuff is this: The problem I see most often from new colored pencil artists' work is that they quit too soon. I see too many pieces that are too airy, lack pressure, have too few layers, lack color and show too little texture. My best advice for novice color pencil artists is to be patient, use the value viewer and keep on going. Don't quit with three layers if eight would be better. I know it's a slow medium, but you'll be much happier with your results if you hang in there!

Realism vs. Photorealism

My particular bent is realism and although my colored pencil paintings are realistic, they are not photorealistic. What's the difference? There's quite a bit of interpretation in my work in that my main goal is to try to find the very easiest way to render something without actually having to paint it. Sound confusing? In other words, I'm always trying to find the easiest way to paint grass without having to paint individual grass blades. I'm virtually never a slave to the photo reference, as you'll see throughout the demonstrations in this book. Once I feel I understand the color and texture of what I'm trying to portray by looking carefully at the photo reference, I intuitively go from there. I'm always looking for what I call the *system*. The system is the combination of pressure, color and stroke that will let me paint an object so it looks like the real thing without actually painting every nuance of the real thing. Although I have tremendous respect for photorealism, I simply don't have the patience for it!

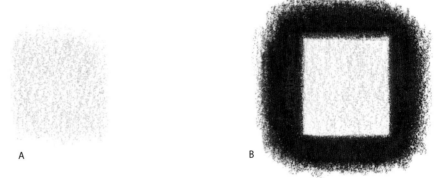

A B

Values Affected by Neighboring Values
The pink surrounded by white in example A is darker than the pink surrounded by black in example B, although they are the exact same value. Surrounding value and hue can make a very big difference in how we perceive a color.

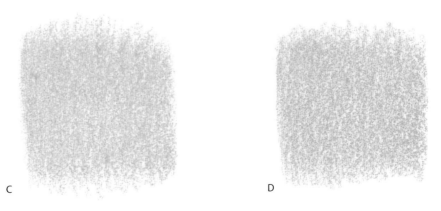

C D

Build Richness With Color
I've layered Blush Pink and Jasmine in example C to create virtually the same hue as the single-layer Peach in example D, but with more depth, intensity and richness of color.

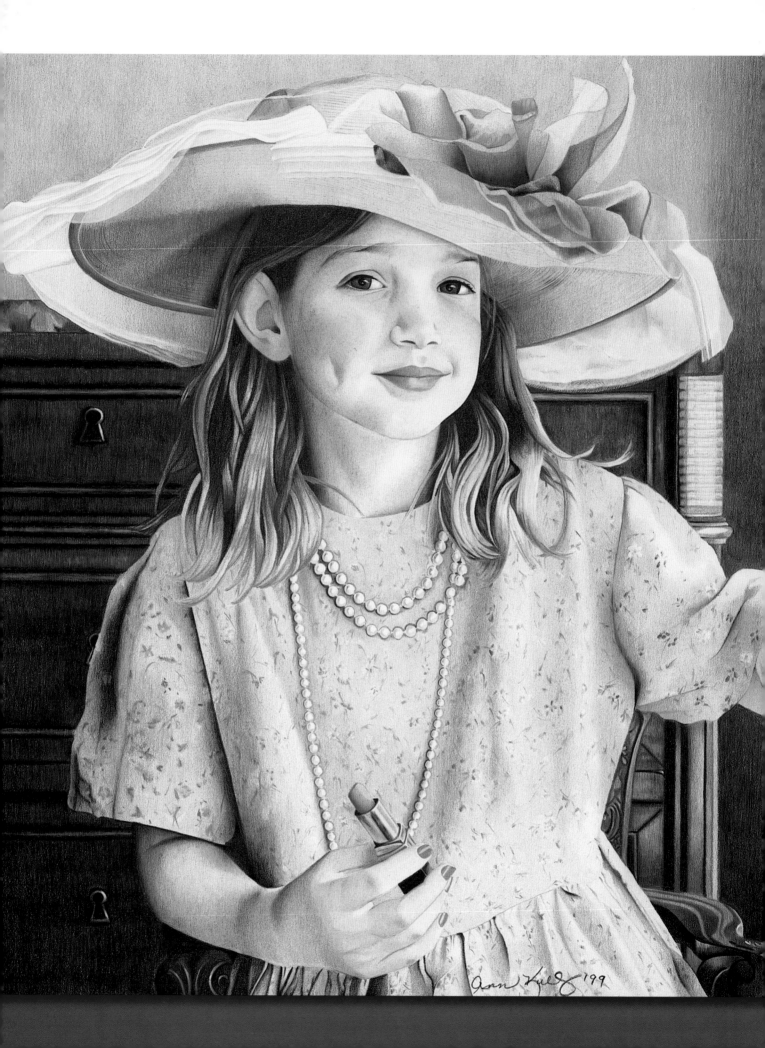

Interiors

This section will give you a sample of various textures, colors and surfaces that you can learn from to help you with your own colored pencil paintings. What you will need to keep in mind, of course, is that the process, not the product, is important with this sort of step-by-step book. Hopefully, in seeing how I create the full "fluffiness" of my pillows, you'll learn to create your own!

Julia
20" x 27" (51cm x 69cm)
Collection of Marcia Weiss

Wicker Basket and Drapes

Wicker may seem like a bear to paint, but I've found it to be relatively easy once you get into the rhythm. My main idea in approaching wicker is to make sure I don't get too detailed. I want to find the system that will allow it to look like wicker without actually having to draw each individual cane. My first question when tackling any relatively complicated texture or pattern is, "How can I paint this without actually painting this?" Colored pencil is so slow that I'm always looking to find the fastest way possible to make something look realistic without actually having to do all the dirty work! Applying the darks first really helps in figuring out the pattern in a basket or wicker.

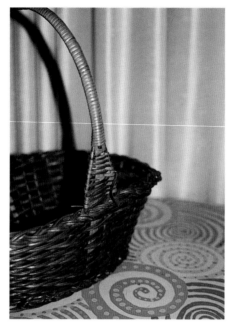

Reference Photo

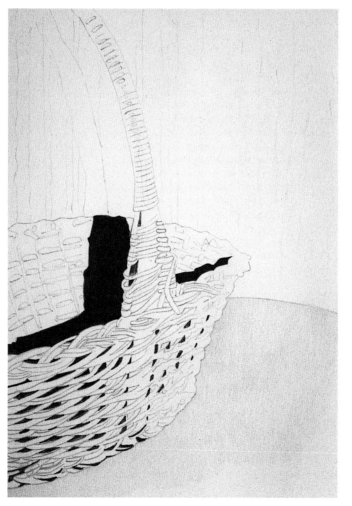

Colored Pencils

Black
Black Grape
Burnt Ochre
Clay Rose
Dark Brown
Dark Umber
French Grey 90%
Henna
Jasmine
Light Peach
Light Umber
Lilac
Mineral Orange
Pale Vermilion
Peach
Pink Rose
Pumpkin Orange
Rosy Beige
Sepia
Sienna Brown
Slate Grey
Terra Cotta
Tuscan Red
Yellow Ochre
White

STEP 1: ESTABLISH THE DARKS

Begin the basket by laying in the darkest dark with a heavy (4 pressure) coat of Black, followed by a second heavy layer of Tuscan Red. No sense in keeping too sharp a point with these heavy layers because the point will just break, so use a slightly dull pencil for both layers. Next, study the pattern of the interwoven strands and fill in the darkest shadowed areas in the front of the basket with Tuscan Red (4 pressure). You might notice that the line drawing is relatively loose. Draw the basic pattern without getting too detailed or exact because you are really more interested in drawing something that looks like a basket rather than drawing every strand you see in the photo reference. Throw in a quick wash of Pink Rose on the tabletop (2 pressure).

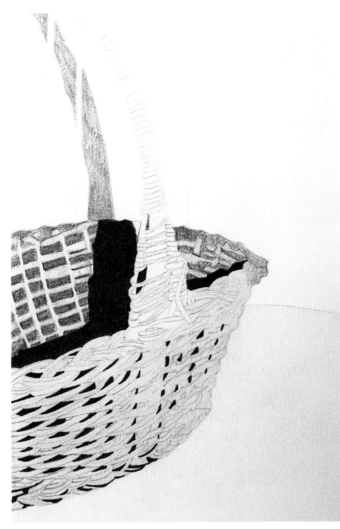

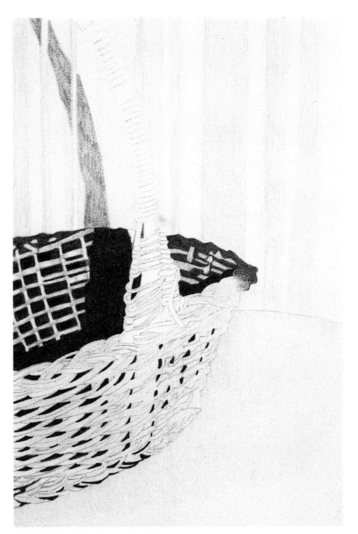

STEP 2: FIRST WASHES

Basket

Start to darken the inside of the basket with a slightly dull Dark Brown (2–3 pressure) to fill in the basic darker shapes. Then wash the handle with a light coat of Jasmine using a vertical line stroke, but use a heavier touch and a directional line to separate the strands of the handle. Finally, wash all but the basket highlights with Peach, varying your pressure (1–2), using a slightly dull point.

Drapes

Start the drapes by filling in the handle shadow with a loose, quick wash of Light Umber (2 pressure).

STEP 3: DEEPEN THE DARKS

Basket

Bring the darks in the inside of the basket to nearly the same value as the shadow by layering Dark Brown and Tuscan Red in the darkest areas (4 pressure). Outline each of the box shapes before filling them in with these two layers. Add a little color to the lighter strands inside the basket using Henna, leaving the highlights uncovered.

Drapes

To make the folds of these drapes look realistic, avoid using a ruler when drawing the vertical lines of the folds. Using a straightedge will make the drapes look too angular and less like cloth. Begin with a wash over the entire drape area with a light layer of Light Peach with a vertical line stroke and a scribble stroke, using a slightly dull point (2 pressure). Now Add Pink Rose to the darker folds with the same stroke and pressure as the previous layer. Use a tiny bit of Peach along some of the edges where you see a warmer tone in the photo reference.

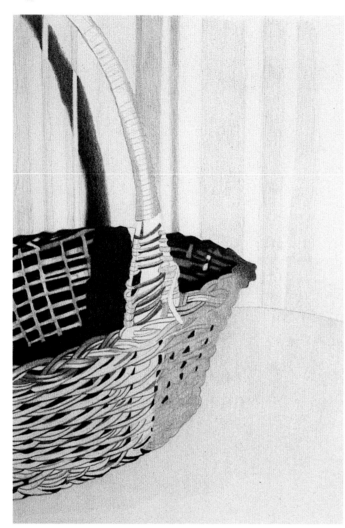

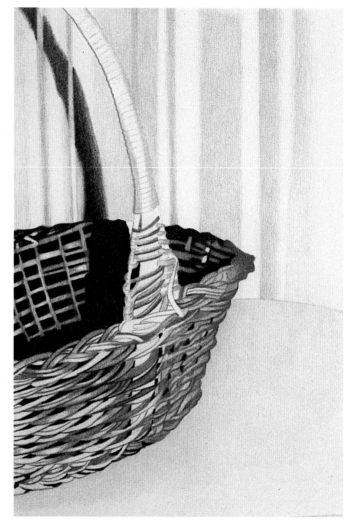

STEP 4: ADD COLOR

STEP 5: SEPARATE THE STRANDS

Basket

The inside darks still aren't dark enough, so use Black Grape (5 pressure) to really push these darks. Then build up the light areas of the inside with Burnt Ochre and Sienna Brown, varying your pressure (1–3). Add Mineral Orange to the handle and to the right side of the basket front using a scribble stroke (2-3 pressure). Add a bit of detail to the strands at the bottom of the handle using Sienna Brown and Terra Cotta. Outline the graphite lines with Terra Cotta to begin separating the strands you drew.

Drapes

Add Mineral Orange to the darkest fold, then begin some modeling with Rosy Beige and Clay Rose. Keep a dull point with these scribble layers so the outer edges will remain soft.

Basket

Outline the shadow side of the handle with a fairly heavy coat (sharp point) of Pale Vermilion. Soften some of the highlights found inside the basket with Henna, using a dull point and a light touch (1–2 pressure). Now separate some of the strands of the right front, using Sienna Brown (3 pressure) and a slightly dull point, on top of the Mineral Orange layer. On the left front, continue using Sienna Brown, fill in all but the highlights then separate some of the strands with Dark Brown.

Drapes

Continue to build color with Rosy Beige and Clay Rose, lightening your pressure toward the outer edges to keep them very soft.

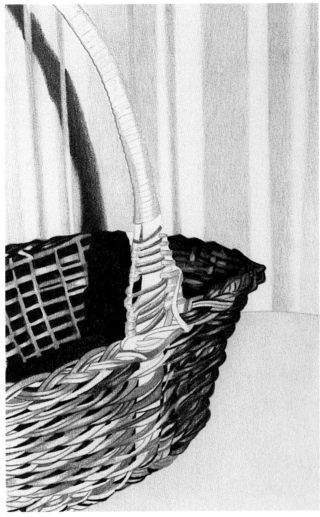

STEP 6: BRING UP THE DARKS

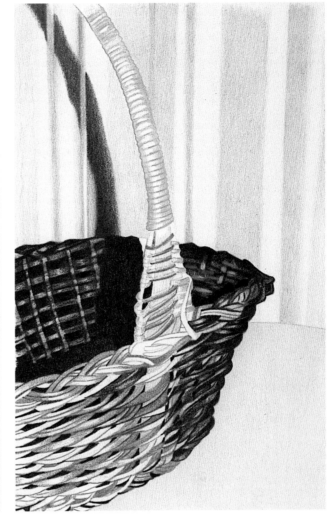

STEP 7: FINISH THE INSIDE OF THE BASKET

Basket

Begin darkening and adding detail to the right front using a slightly dull Dark Umber (3–4 pressure), outlining strands and filling in all but the lightest spots. Cover most of the same area with Black to really deepen the darks.

Basket

You can't finish the front until the inside is complete. Use Sepia and French Grey 90%, in a loose directional stroke (3–4 pressure) and darken most of the strands. Add a bit of Yellow Ochre to the piece that connects the handle to the basket base, then use Pumpkin Orange (3 pressure) with a sharp point on both sides of the handle and through the middle of the wrapped section of the handle.

Drapes

Add a bit of color using first Peach then Mineral Orange using a dull point, and lightening your pressure as you come out of these shapes to soften the edges.

Q & A

Q: Why do you use French Grey more than the other grays?

A: I tend to have a very warm palette. That means that I prefer colors on the warm, yellow/red side to the blue/purple side. The French Greys are much warmer than the Warm or Cool Greys, as you can see from these swatches. I generally reserve Cool Greys for metallic and manmade objects, although I do occasionally mix them among layers of the Warm and French Greys.

Cool Grey 30%

Warm Grey 30%

French Grey 30%

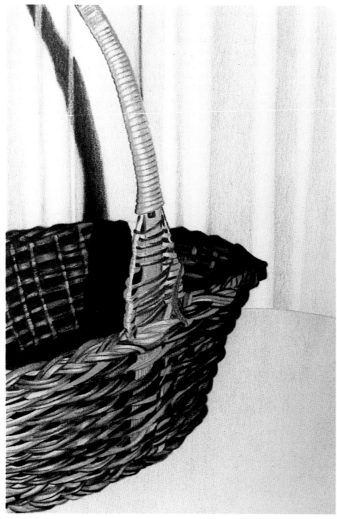

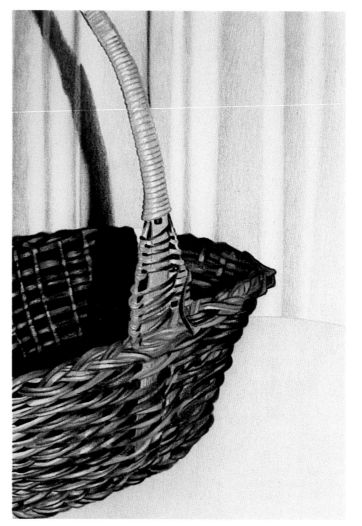

STEP 8: FINISH THE DRAPES

STEP 9: LIGHTEN THE HIGHLIGHTS AND SOFTEN THE EDGES

Basket

Add a tiny shadow with a sharp Terra Cotta to the left side of the handle, then darken some of the loose strands wrapping the bottom of the handle with Tuscan Red (2–3 pressure).

Add touches of Lilac and Slate Grey to the highlights inside the basket then move on to the left basket front by first covering all but the highlights with Mineral Orange using a directional stroke (3 pressure). Over the Mineral Orange, lay in some Dark Brown and Dark Umber, trying to find and define the darkest strands. Add a bit of vertical detail with a sharp Light Umber to the piece that connects the handle to the basket.

Drapes

Add a slight touch of Light Umber then Dark Brown to the darkest fold in the drapes.

Basket

Using Pumpkin Orange, Terra Cotta and Pale Vermilion, make the color of the basket reeds richer, warmer and darker. Vary your pressure with these three colors to build depth. The last step is to burnish the middle of a few of the highlights with White. This step not only slightly lightens the highlights, but it also helps to soften the edges of the highlights when you work the White slightly into the dark areas.

Upholstery and Pillows

I'm sneaking in a couple different lessons in this demonstration. In addition to a sofa and pillows, you're getting stripes and plaid at the same time! The trick with upholstery and pillows is to pay careful attention to the light and shadow—it's all in the puckers! Actually, the most interesting thing about this demonstration may be how I transferred it to my drawing paper. I put the slide reference into a normal slide projector. Using sticky stuff I attached a piece of Stonehenge paper to the wall and projected the image on the paper. Because the stripes on the sofa are so narrow and close together, I traced the stripes with a Blue Slate colored pencil rather than a graphite pencil. I rarely use a colored pencil when transferring because they are so much softer than graphite, and you have to sharpen constantly while tracing. If you don't keep your pencil sharp, your lines will become too thick and inaccurate. With this drawing that works to my benefit, as the pencil lines can represent an entire stripe with the thickness of the point on the narrower stripes.

Plaid is one of my favorite subject matters to paint. It always feels like a puzzle to be figured out. Although intricate, it's usually not difficult, just a matter of squares and lines!

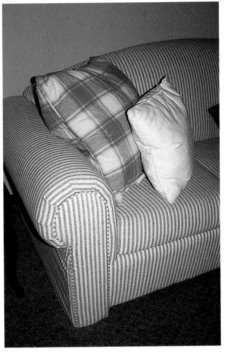

Reference Photo

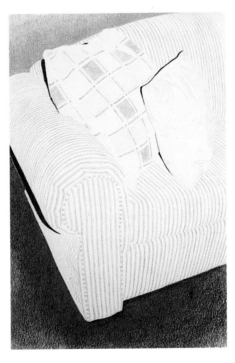

Colored Pencils

Black
Blue Slate
Deco Aqua
Deco Yellow
French Grey 20%
French Grey 30%
French Grey 50%
French Grey 70%
French Grey 90%
Jasmine
Light Aqua
Light Umber
Peacock Blue
Slate Grey
Ultramarine
Yellow Ochre

STEP 1: ROAD-MAPPING

Sofa

Build the wall with a wash of Deco Aqua using a scribble stroke and a slightly dull point (2 pressure). Finish the wall using Light Aqua and a slightly dull point and a scribble stroke (2-3 pressure). Begin the sofa by filling in the stripes with a very sharp Blue Slate pencil and a fairly light touch (2 pressure).

Pillows

You need to understand this plaid. Begin road-mapping by filling in the blue squares with Blue Slate (1.5 pressure). Use Deco Yellow in the larger yellow areas. On the solid pillow lightly (1.5 pressure) layer Jasmine everywhere except for the highlights and the piping. Establish a dark area using Black with a heavy pressure (4) for the hard shadows.

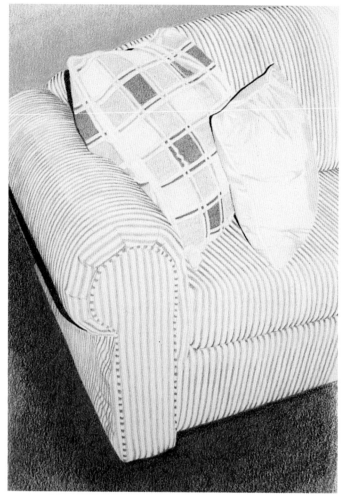

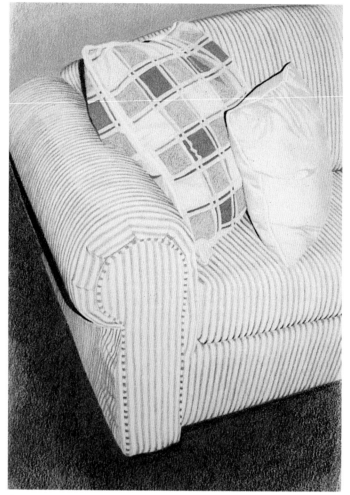

STEP 2: DEFINE FORM

Sofa

The depth and form of this striped sofa can be portrayed entirely by value. Go over most of each stripe with Slate Grey, but leave the highlighted portion uncovered. The sofa arm and cushions will "magically" curve and attain form.

Pillows

Begin to darken the blue with a fairly light touch (2.5 pressure) of Ultramarine. Cover the rest of the plaid pillow with Deco Yellow. Create a few of the shadows and puckers on the solid pillow with French Grey 30%, varying your pressure (.5–1.5).

STEP 3: FINISH THE SOFA

Sofa

Finish the sofa (wasn't that quick?) by adding a light layer of French Grey 20% to the white stripes that are between the darker stripes. Use a small amount of French Grey 90% (3 pressure) on the blue stripes that are on the bottom of the top cushion and on the bottom of the leg.

Pillows

Use Peacock Blue on the darker blue squares and stripes. Over the Deco Yellow squares, layer a light coat of Slate Grey (2 pressure) with a fairly dull point so part of the yellow will show through. Use Jasmine for the folds on both pillows (3 pressure).

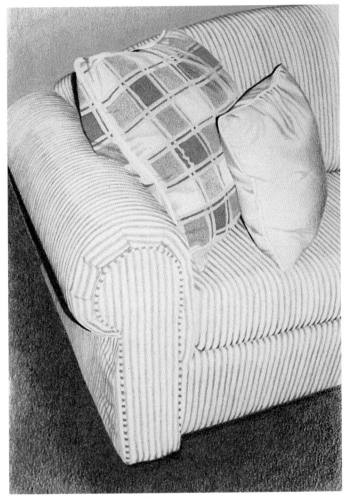

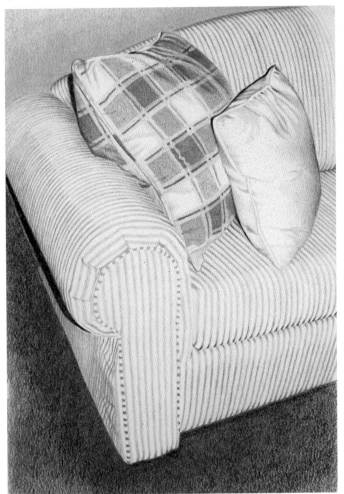

STEP 4: CREATE RICH DARKS

STEP 5: DARKEN THE SHADOWS

Pillows

Layer Deco Yellow (3 pressure) followed by French Grey 30% (3 pressure), then Light Umber (3 pressure) to darken the shadows of the solid pillow. Next use Blue Slate (3 pressure) one more time on the darker squares of the plaid pillow. Darken the folds with French Grey 30%.

Pillows

Darken the shadows on the plaid pillow one last time with French Grey 70% (varied pressure). Lightly skim a little Ultramarine over some of the deeper shadows. Layer a little more Yellow Ochre on the solid pillow, then fill in the light areas with Deco Yellow (2 pressure). Outline the piping with a very sharp Yellow Ochre. Add touches of French Grey 50% and Light Umber to the shadow of the solid pillow.

Carved Wood

The beautiful richness of color, shadow and highlight make painting an object like this carved wood chair a real joy!

Reference Photo

Colored Pencils

Black
Blue Violet Lake
Burnt Ochre
Dark Brown
Dark Umber
Goldenrod
Henna
Indigo Blue
Jasmine
Mahogany Red
Pale Vermilion
Peach
Pink Rose
Pumpkin Orange
Sienna Brown
Tuscan Red

STEP 1: BUILD THE BACKGROUND

You don't want to work on a light area until your darks are established, so your first step is to build a corresponding dark ground behind the chair. Layer Tuscan Red, Dark Umber and Black using the scribble stroke (3–4 pressure). These three colors are a great combination for building a warm, rich dark. After establishing the dark, check the photo reference. The top part of the chair has a pink-ish tone, while the lower part of the back and arm are warmer and more yellow. Create a light wash of Pink Rose (1.5 pressure) on the top section and Jasmine (1.5 pressure) below, saving the highlighted areas. Leave these spots untouched until the end. Use Sienna Brown to outline some of the graphite lines that might be lost while building layers of color.

STEP 2: ROAD-MAPPING

Over the first layer, use Dark Brown to find the very darkest areas (3 pressure). Finding and road-mapping these will help you keep track of where the light and dark areas are and will keep you from getting confused in the more detailed areas. Once these darkest areas are mapped out, wash over the next darkest area with the same Dark Brown pencil using a light pressure (1.5) and a smooth vertical line stroke.

Q & A

Q: How do I maintain the graphite lines of my initial drawing?

A: Lightly trace the graphite lines with a neutral shade of the color you will be using to draw your subject. I often do this early on in the layering process if I think I may lose important lines under layers of colored pencil.

STEP 3: ESTABLISH THE DARKS

Concentrate on the darkest areas of the wood before moving on to the midtones and highlights. Use Pumpkin Orange for the warm part of the chair and Tuscan Red for the cooler back area. You want this to eventually have a smooth, polished wood texture, so use the smooth vertical line technique throughout the layering on the chair. These layers are not washes; the pressure varies between 1 and 3. In most areas, use about a 2 pressure. To avoid hard edges, lighten your pressure (1) as you come out of a dark area. Begin modeling by darkening areas that recede; in a few spots, increase your pressure (3).

STEP 4: DEEPEN THE DARKS

Bring the darks nearly to completion at this stage by layering Tuscan Red, Dark Umber and touches of Black (3–5 pressure) on the very darkest areas in the lower section, using a sharp point. Lightly layer Tuscan Red over the back of the arm. Since the upper back section is so much cooler, use Indigo Blue and Black to darken these darks.

STEP 5: BLEND THE MIDTONES

Layer Goldenrod (3 pressure) over most of the lower section to blend these areas. You still don't want any hard edges, so lighten the pressure as you come out of a darker area so all edges are soft. This softening of the dark areas helps the eye to read the wood as curved slightly, since the highlight gradually darkens as it curves around the wood. On the upper back, layer Henna (2–3 pressure).

STEP 6: COMPLETE THE DARKS

Use Mahogany Red and Black (2–4 pressure) to finish building the darks. Go back and forth with these two colors—begin with a little Mahogany Red, add a little Black, then back to a layer of Mahogany Red with maybe a final touch of Black. Working back and forth makes a richer, fuller dark. Darken the inner curve of the outer edge of the arm using Dark Umber and Black.

STEP 7: MIDTONES AND HIGHLIGHTS

Layer Pale Vermilion (1–4 pressure) over the midtones of the lower area to create the bright rich, warm, reddish undertones of the wood. This layer will be a little too bright, but you can take it down with a duller color in the next layer. Nearly burnish the midtones with Pumpkin Orange (4 pressure) to blend the layers together and create a polished look. On the upper section, work the highlights with light layers of Pink Rose, Blue Violet Lake and occasional touches of Tuscan Red (1–2 pressure). Make sure the top and lower sections don't look completely unrelated to each other by adding some warm tones to the upper section using Burnt Ochre. Use Pink Rose and Peach very lightly (1 pressure) to soften the highlights, especially around the edges.

STEP 8: FINISHING TOUCHES

Add some detail by darkening some of the upper highlights with Dark Brown and Dark Umber. In the lower arm, refine the highlights by separating them, using Tuscan Red and Dark Brown. Vary the values by layering a little Henna, Peach and Pink Rose over them with varying degrees of light pressure.

Wood Grain Floor

When working on an object with grain texture—like this wood floor—you don't want to become a slave to the photo reference. Study the photo carefully in the beginning to get a feel for the grain. Place a few of the more obvious markings, but after that, wing it! You'll spend more time than you need if you follow every nuance of the grain, and the result won't be better than if you just follow your gut in placing some texture into the floor. The only thing you have to worry about is to avoid making the grain lines too uniform. Don't make all the lines and squiggles the same value, length, width and distance apart and you'll do fine!

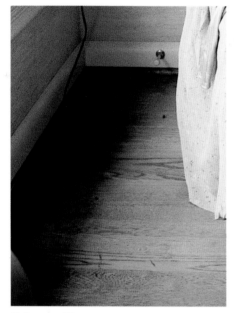

Reference Photo

Colored Pencils

Beige
Black
Burnt Ochre
Cream
Dark Brown
Dark Umber
Cool Grey 10%
French Grey 20%
French Grey 50%
French Grey 90%
Goldenrod
Jasmine
Light Umber
Mineral Orange
Pink Rose
Sand
Slate Grey
Yellow Ochre

STEP 1: FIRST WASHES

Begin the wall with a wash of Beige using a slightly dull point and the scribble stroke (2 pressure). Apply Jasmine using the same stroke and pressure. Use a dull point and the scribble stoke to apply French Grey 50% (1 pressure). Use a scribble stroke to wash the floor with Sand (2 pressure). You want to cover the white of the paper; do not worry about the smoothness at this point. Layer Dark Umber on the molding to the left, then Light Umber on the far molding to begin to establish the dark areas, using a light touch and a vertical quick stroke. Begin modeling the floor using a scribble stroke to place Yellow Ochre on the shadow side (2 pressure) and on the right (1 pressure). Lay in some of the darker wood grain pattern with Dark Brown (2 pressure).

STEP 2: ESTABLISH THE DARKS

Apply Goldenrod in a fairly heavy layer (3 pressure) over the Dark Umber to introduce warmth to the molding and to provide a fairly waxy base for subsequent layers. Use a scribble stroke—you've got more layers to go and the stroke won't show in such a dark area. Use Black directionally, rather than vertically, for the darkest darks. Use a sharp point to really fill the paper surface and get dense coverage and a quick stroke to cover the molding with Dark Umber (3 pressure), leaving a thin line for the highlight. Darken it with French Grey 90% and a smooth stroke to finish the darks.

Now move on to the floor using a scribble stroke in Mineral Orange with a 2 pressure on the lighter side and a 3 pressure in the shadow. Follow with a light layer of Light Umber (2 pressure) over the left side.

STEP 3: BUILD COLOR

Use Burnt Ochre with a very light touch on the right side but a fairly heavy (3.5 pressure) touch on the shadow. Use a very sharp point on the left side to fill the tooth and achieve full, even coverage. You don't want too many overlaps at this point because it will fight with the wood grain texture. To avoid this conflict, switch to a smooth stroke.

STEP 4: LESSEN THE INTENSITY

The paper surface is really filling up now on the shadow side, so use more pressure and make sure your point is very sharp as you cover the shadow area with a layer of Dark Brown (4 pressure). Add a lighter (3 pressure) layer of Black in the darkest areas of the shadow (against the molding). Before adding any more color to the lighter wood, layer French Grey 20%. This gray will help to ensure that the wood doesn't start to look garishly yellow! Next use Goldenrod and a quick stroke to start defining a few of the boards.

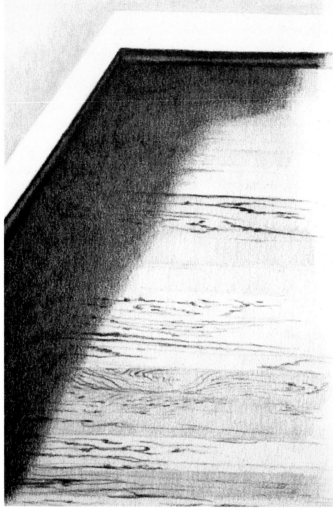

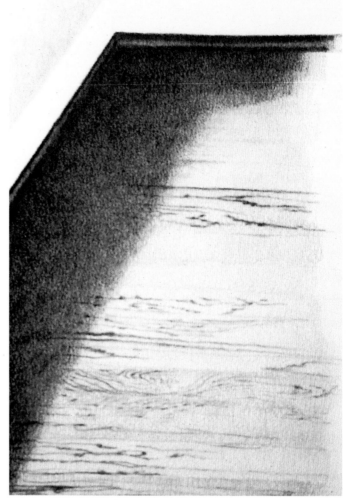

STEP 5: FINISH THE DARKS

STEP 6: ADD TEXTURE AND PATTERN

Complete the shadow area by laying in a heavy coat of Dark Umber using a sharp point and a smooth stroke. Darken the grain lines one more time with Black, going into the shadow area slightly with some of the darker lines.

Make the floor look more solid and less airy using Sand (which is slightly darker than Jasmine) and a sharp point. Nearly burnish all of the lighter wood using a smooth stroke (4–4.5 pressure).

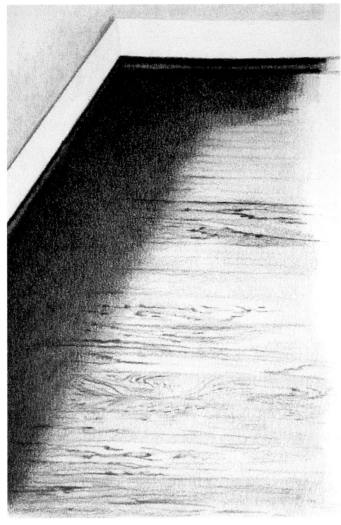

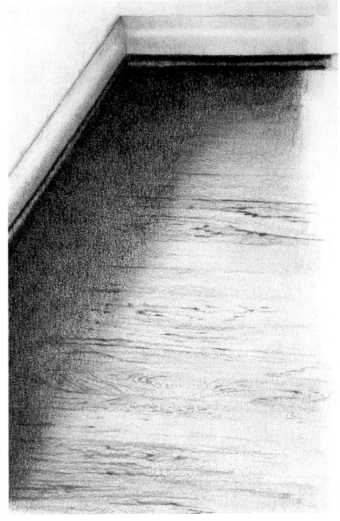

STEP 7: ADD THE GRAIN

Using Light Umber in a horizontal, directional stroke, randomly add grain details and define a few of the individual boards. When adding grain, be sure that your pressure and line width vary; if these lines are too similar, they'll look false and unrealistic since virtually nothing that is natural is uniform.

Go over some of the boards with Burnt Ochre (1–3 pressure). Use more pressure near the edge of the shadow to soften the edge. Using a color on the edge that is lighter in value than the shadow but darker in value than the floor—like Burnt Ochre—will help blend these two together. Start on the molding by applying a quick layer of French Grey 20% on the left side and Cream on the back molding.

STEP 8: ADD DETAIL

By now you should have the correct amount of texture, so it's time to do some blending, evening out and pulling together. Use Goldenrod with a smooth stroke (3 pressure). Increase the pressure near the shadow. Next cover the entire floor again with Light Umber, this time nearly burnishing the edges of the shadow.

Layer French Grey 20% on both moldings, varying the pressure to increase and decrease the value. Place Slate Grey on the left side only, being careful to leave a highlight area. On the back molding trim the highlight with a tiny bit of Yellow Ochre followed by Pink Rose. It is a tiny bit bright, so burnish the edges of the highlight on the back molding with a Cool Grey 10%.

Patterned Carpet

Since it's highly unlikely you'll ever be painting this exact carpet, the colors here aren't as important as the sequencing of my steps and my use of short, choppy scribble strokes to add texture to give this carpet the feeling of pile and depth.

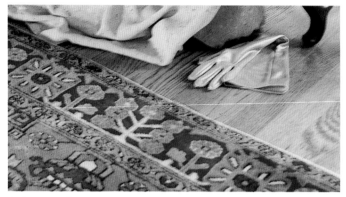

Reference Photo

Colored Pencils

Black
Deco Aqua
Deco Pink
Deco Yellow
French Grey 30%
French Grey 70%
Hot Pink
Indigo Blue
Jasmine
Light Aqua
Light Umber
Non-Photo Blue
Pale Vermilion
Peacock Blue
Peacock Green
Peach
Pink
Poppy Red
Pumpkin Orange
Raspberry
True Blue
Yellow Ochre

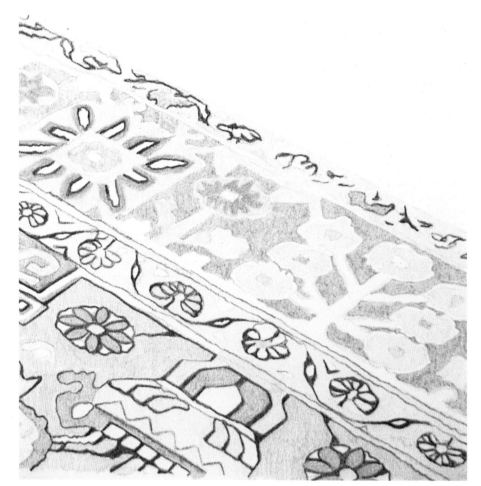

STEP 1: ROAD-MAPPING

If road-mapping was ever essential, it's with a complicated piece like this! You need to know where everything is first, so with a relatively light (2 pressure) touch throughout, begin filling in the following colors: Non-Photo Blue, Deco Yellow, Deco Pink, Deco Aqua, Peach, Pale Vermilion and French Grey 70% over the lines defining each pattern. All of these colors are in the pastel range and your main objective is to sort out the pattern, so start very light!

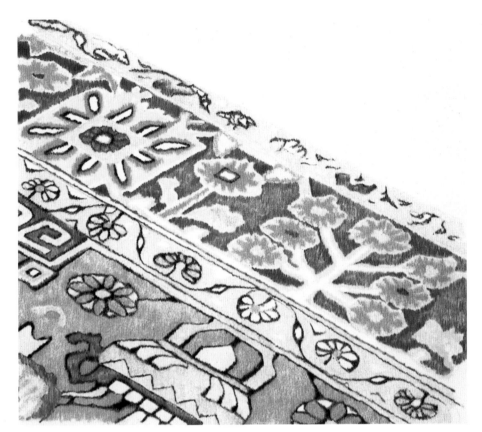

STEP 2: BUILDING DARKS

Place your darkest darks in quickly to set the tone for the carpet. Use a sharp point to fill the tooth of the paper and a scribble stroke (3 pressure) to apply True Blue to the blue area. Start building texture with Peacock Blue using a loose scribble stroke (4 pressure) and allowing the previous layer to show through. With random broken scribble strokes, darken this area with Indigo Blue. Layer Jasmine over the yellow areas using a scribble stroke. Go over the red areas of the carpet with Poppy Red and a scribble stroke (4 pressure). Go over the lines again with Black.

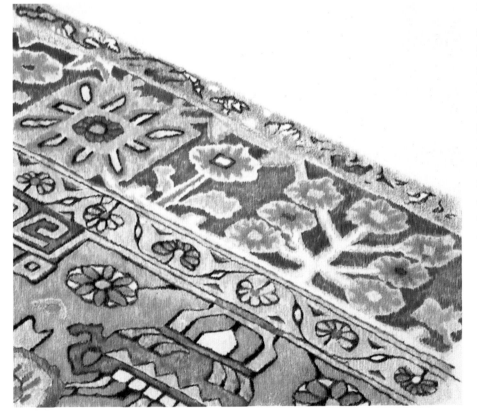

STEP 3: ADD TEXTURE

Continue to darken areas of the carpet with increasingly darker values of color in each range. Scribble Yellow Ochre first and then Light Umber over the yellows. Use Pink followed by Hot Pink over the pinks. For the greens, use Light Aqua then Peacock Green. Make sure that the strokes are very rough and choppy where two edges meet to achieve the feel of the carpet's pile. The blues aren't dark enough, so add a bit of Indigo Blue here and there. Grey down the whites with French Grey 30%.

STEP 4: INCREASE VALUES

Increase the richness of the values by darkening all areas using the same colors but with a heavier pressure. Use Pale Vermilion and Poppy Red over the pink areas. Use very short, choppy strokes for much of these colors to introduce more texture and depth.

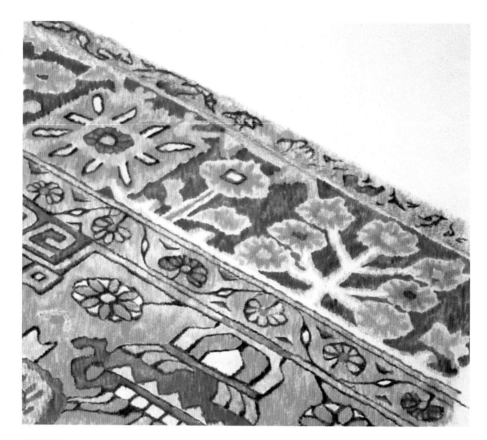

STEP 5: DULL THE COLORS

The colors are dark enough now but too bright. Dull the reds with a light (1.5 pressure) coat of Raspberry. Dull the blues and greens with French Grey 70%. Go over the pinks with some Pumpkin Orange followed by a light scribble of Light Umber. Add a bit of French Grey 30% over the white areas, and the carpet is complete.

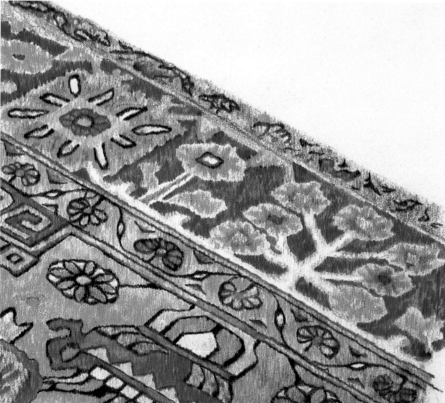

Windowsill

I use a straight edge for all of my lines in the first step of this windowsill. However, I don't use it in subsequent steps. I want my lines to be relatively straight—not too straight—or the painting will look like an architectural drawing. With an architectural subject like this, the most important thing is to pay very close attention to value. Constantly use your value viewer; the value changes of each of these thin pieces of molding create depth.

Colored Pencils

Blue Slate
Black Grape
Clay Rose
Cool Grey 30%
Cool Grey 50%
Cool Grey 90%
Dark Brown
Dark Umber
French Grey 20%
French Grey 30%
French Grey 50%
French Grey 90%
Greyed Lavender
Jasmine
Light Umber
Mahogany Red
Pink Rose
Rosy Beige
Slate Grey
Warm Grey 70%

Reference Photo

STEP 1: FIND THE DARKS

Fill in the dark panes with French Grey 50% and Cool Grey 50% using the scribble stroke and a slightly dull point (2 pressure). Mix the French and Cool Greys to add interest and create a neutral color. Add a little Black Grape with a broken scribble stroke (1–3 pressure) and a slightly dull pencil. Use French Grey 90% and Dark Umber to add a few random, dark vertical strokes using a slightly dull point (3–4 pressure).

Use French Grey 90% on the darkest lines except on the bottom edge of the frame; there, use Slate Grey. Use French Grey 30% on the midtones, followed by Pink Rose. Use smooth strokes (1–2 pressure).

STEP 2: ADD COLOR

There's a fair amount of color in this "white" windowsill. Layer Greyed Lavender over the Pink Rose.

STEP 3: ADD MORE COLOR

Darken the larger board on the left using a layer of Mahogany Red over the Greyed Lavender. Use a 3 pressure near the tip, but lighten your pressure to a 1 as you move down the board. Darken a few of the other shadows with French Grey 30% and Cool Grey 50%.

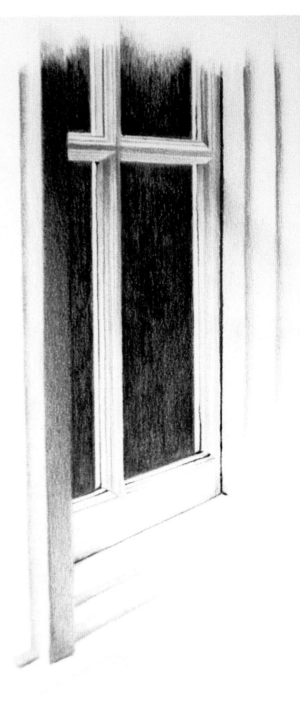

STEP 4: DARKEN THE LEFT SIDE

Darken the left side with Dark Brown (4 pressure) near the top, but decrease pressure on the way down. Next use a Cool Grey 50% to darken the shadow and define the lines here and there.

STEP 5: FINAL TOUCHES

Use Dark Umber on the top of the left side to darken the board. Switch to Warm Grey 70% about halfway down and then switch to Slate Grey near the bottom. At the top lightly (1 pressure) add a bit of Cool Grey 90%. Add Light Umber to the bottom of the frame.

To describe the final touches of this exercise is nearly impossible. Add a touch of this and that here and there to finalize the image. Use the following colors in no particular order: French Grey 20% and 30%, Cool Grey 30%, Light Umber, Clay Rose, Rosy Beige, Pink Rose, Blue Slate, Greyed Lavender and a little Jasmine.

Walls

There may be times when you want a plain, flat background or simple wall behind your subject. Even if the lighting and values are even throughout your photo reference, I'd encourage you to choose one area that gradually becomes darker. You might choose to increase the value from top to bottom, bottom to top, left to right, right to left, or in a halo around your subject. By adding a gradation of color to your wall or flat background, you can add interest and mood to your painting. And it's easy to do!

Colored Pencils

- Blue Slate
- Celadon Green
- Cloud Blue
- Cream
- French Grey 20%
- Light Cerulean Blue
- Sand
- Yellow Ochre

STEP 1: FIRST WASHES

Start each flat background on the left (1 pressure), gradually increasing as you move toward the right (3 pressure). Use the smooth stroke for all of these swatches. Keep your point quite sharp by turning the pencil as you work and sharpening it often.

Use Cloud Blue for the top example, Cream for the middle example and French Grey 20% for the bottom example.

STEP 2: INCREASE THE VALUE

Increase the value by adding a second layer. Choose a color that is darker in value than the first layer. However, don't start this layer on the far left border; instead, leave a small area on the left covered by only the first layer and start the second layer in from the left border with a very light touch (0 pressure). Very gradually increase your pressure to a 3 as you move right.

Use Light Cerulean Blue for the top example, Sand for the middle example and Celadon Green for the bottom example.

STEP 3: INTRODUCE THE NEXT LAYER

Introduce the next layer with a whisper stroke gradually increasing to a 3 pressure. Begin even further to the right than in Step 2. For a slightly more textured wall, change your stroke to a widely spaced, vertical line quick stroke as used in the middle example. By leaving space between these strokes, you allow more of the previous layers to show through. Notice how the three simple layers can create quite a range of values and add a bit of interest to flat areas.

Use Blue Slate for the top example, Yellow Ochre with a vertical quick stroke for the middle example and French Grey 20% for the bottom example.

Metal Fixtures

For warm metal objects like these, don't forget to add a bit of yellow and orange or red near your highlight areas. This will brighten them up and lend a real glow to your metal reflective surfaces.

Reference Photo

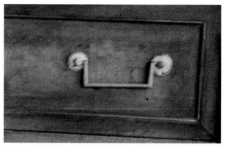

Reference Photo

Q & A

Q: How do you make the keyhole look three-dimensional?

A: The trick is to be very careful about edges and shapes of shadows and highlights. The colors don't matter as much in making it look three-dimensional as does paying careful attention to highlight and shadow placement…and that means paying close attention to values!

Colored Pencils

Black
Burnt Ochre
Cream
Dark Brown
Dark Umber
Deco Yellow
French Grey 30%
French Grey 50%
French Grey 70%
Goldenrod
Jasmine
Light Cerulean Blue
Light Umber
Pale Vermilion
Peacock Blue
Sand
Slate Grey
Ultramarine
Yellow Ochre

STEP 1: BACKGROUND

The wood behind these fixtures is dark, so you know what you need to do first! Build a background by quickly laying in Yellow Ochre, Goldenrod, Light Umber and Burnt Ochre. In the shadow areas and around the keyhole, add a layer of Dark Brown, Dark Umber and a bit of Black. Your next step is to establish the darkest dark, which is inside the keyhole. Using a heavy hand (4 pressure), apply Dark Umber and then burnish it with Black.

STEP 2: WASHES

Keyhole

Begin by working on the left side of the keyhole; this is where you will find the darkest dark. Even though the difference is slight between the left and right sides, it is best to begin with the darkest dark. Begin with Cream then add Deco Yellow on the entire left side except the highlighted area. Deco Yellow is a very clean, clear yellow that is not too bright. With an extremely sharp Yellow Ochre, go over the bottom and top left of the keyhole.

Handle

Wash the handle with Cream to begin with a warm tone. Even the French Greys aren't quite warm enough for metal, so apply a first layer is Cream or Jasmine. Next use French Grey 30% to start modeling the handle, using a directional rather than vertical stroke. Use French Grey 30% for the circle areas, covering all but the highlight with a light (2 pressure) smooth stroke. Use Black to darken the darkest spots (3 pressure).

STEP 3: REFLECTIVE COLOR

Keyhole

Polished metal reflects whatever color is around it, so adding color will help make the keyhole look realistic. Use Pale Vermilion on the bottom edge and under the highlights, varying your pressure (1–3). Next use a little Slate Grey (1–2 pressure) under the highlights and on the top left. Add a touch of Light Cerulean Blue under the left highlight.

Handle

On the darker areas of the handle layer French Grey 70% with a light pressure (2) then cover all but the highlights and Black areas with a medium coat of Sand. Add a hint of Deco Yellow near the highlights.

STEP 4: FINAL TOUCHES TO KEYHOLE

Keyhole

Darken the bottom edge of the keyhole with Light Umber (3 pressure) then apply Deco Yellow delicately over part of the right side. Burnish around the highlight with Yellow Ochre. This is a small area, but you have to use a slightly dull pencil because a sharp point will break when the necessary pressure needed to burnish is applied. Dull the yellow slightly with Light Umber and a hint of Dark Brown. Shape the highlight with a little Slate Grey (2 pressure). The keyhole is now complete!

Handle

The handle looks pale, so add one more layer of Deco Yellow. Layer Ultramarine (for richness) followed by Black (4 pressure) on the darkest areas. Finally, add Slate Grey over the grey areas. There is a hint of blue in the photo reference and the colors will be too lifeless if you stick to a grey palette.

STEP 5: BUILD FORM

Use a French Grey 50% to softly build up the edges of the handle. Use a slightly dull pencil and vary your pressure (0–3), lightening your pressure as you come away from the shading to create a very soft edge. Cover some of the French Grey 50% with Yellow Ochre (2 pressure). On the circle area layer light coats of French Grey 50% and 70% over the Slate Grey of the previous step.

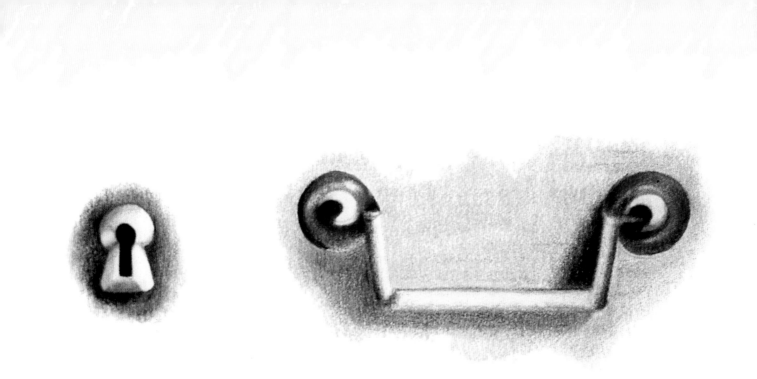

STEP 6: ENRICH THE COLOR

Darken the outer edges of the handle one last time with French Grey 70% with close to a 3 pressure. Use Peacock Blue in the circle area covering much of the gray area. With French Grey 70% darken these areas letting some of the blue show through. Soften the Black areas by nearly burnishing the edges of the Black with French Grey 70%. Layer Deco Yellow followed by Sand over the highlights (3 pressure).

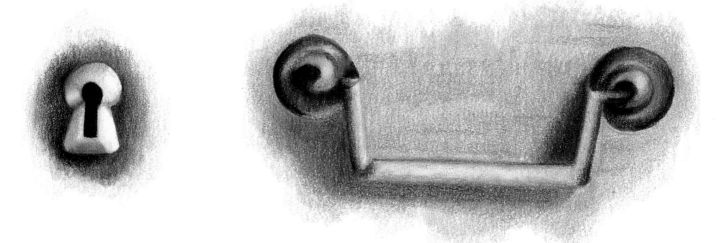

STEP 7: FINAL STEPS

Burnish the highlight areas with Deco Yellow. You want some areas burnished because it works so well for reflective surfaces. Shape the highlight with French Grey 50%. Add a touch of Burnt Ochre (2 pressure) on the left sides of both highlights.

Q & A

Q: Why don't you only use Black inside the keyhole?

A: Black by itself is a pretty dull, uninteresting color. Adding another hue—even one as dark as Dark Umber—can add richness. One of my favorite colors to use under Black is Tuscan Red. I literally never use Black all by itself without adding a color either under or over it.

Patent Leather Shoes

This is a fun demonstration because reflective surfaces like these black patent leather shoes are so fast and easy to make look real—a few well-placed highlights and you're there! Also, almost the only time I get to burnish is when working on something shiny like this. It can be fun pushing the waxy pigment around.

Colored Pencils

Black
Copenhagen Blue
Deco Blue
French Grey 30%
French Grey 50%
French Grey 90%
Indigo Blue
Jasmine
White
Yellow Ochre

STEP 1: FIRST WASH

Begin by outlining the highlights with Black, leaving extra space around each highlight. Better to have too much space for the highlights than too little. Wash the shoe with Black using a vertical line quick stroke (2 pressure). You will be building several layers and nearly burnishing this patent leather, so don't worry about smoothness with this layer.

STEP 2: BUILD COLOR

Cover the Black with a layer of Indigo Blue, using a fairly heavy pressure (3.5). The layer of Indigo Blue adds some richness to the black patent leather. Black is a flat, dull color, so never use it alone without at least one layer of another dark color over or under it. Switch to the vertical line smooth technique before you get too many overlap patterns!

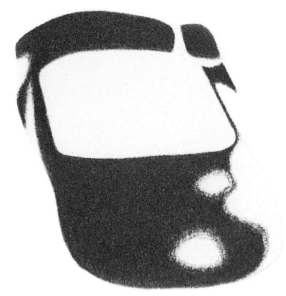

STEP 3: ADD MORE BLACK

Add a layer of Black (4 pressure), still avoiding the highlights.

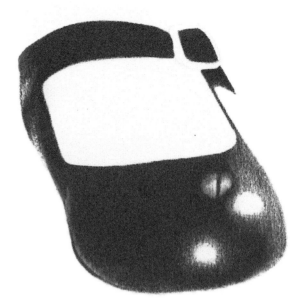

STEP 4: BURNISH

The shoe needs a little more density, so layer Black one more time, this time burnishing (5 pressure). Take White with a slightly dulled point (you'll be using a lot of pressure and don't want the point to break) and burnish inside and around the edges of each highlight. Leave the very center of each highlight untouched allowing the white paper to remain.

Add a hint of highlight to the front left side of the shoe with White over the top of the layers of Black, using a light pressure and a smooth stroke. Outline the buckle with Yellow Ochre.

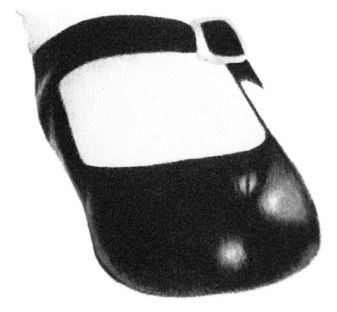

STEP 5: ZOOM IN ON THE HIGHLIGHTS

Narrow in on the actual highlight spots by covering everything but the areas that will be left nearly white by layering French Grey 50%, using a smooth stroke. Vary your pressure from a 1 near the center of the highlights to a 3 as you blend this into the burnished Black areas.

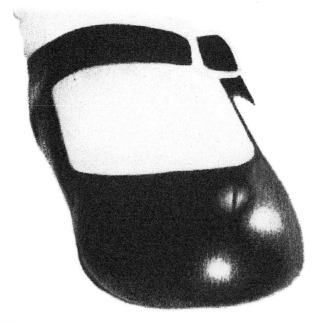

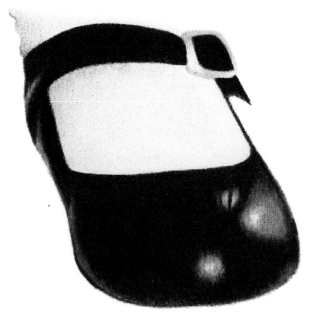

STEP 6: BRIGHTEN THE BLACK

The patent leather still looks dull—too much Black and Grey! Lightly cover (2 pressure) all the French Grey with Copenhagen Blue.

STEP 7: FINISHING TOUCHES

Burnish the edges of the highlights again with White, going deeper into the center this time. Use French Grey 50% and 90% to blend the outer edges into the black part of the shoe; vary the pressure (3–5). Finally, use a hint of Deco Blue over the lightest part of each highlight to add a little life. Use a bit of Jasmine, then French Grey 30% on parts of the buckle (2–3 pressure).

Tennis Shoes

The fun part about this demonstration is showing you how easy it is to create the look of stitching on a tennis shoe (or on any fabric!) and how little needs to be done to make shoelaces look like laces.

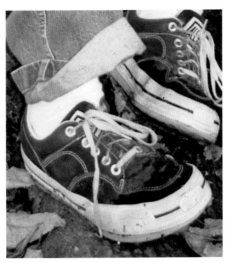

Reference Photo

Colored Pencils

Clay Rose
Cool Grey 50%
Cool Grey 90%
French Grey 20%
French Grey 30%
French Grey 50%
French Grey 70%
Greyed Lavender
Indigo Blue
Jasmine

STEP 1: WASH

Start with a midtone wash of French Grey 30% to wash the darker areas; use a smooth stroke (3 pressure). Leave a strip of white wherever there is stitching, as you'll work on that detail last.

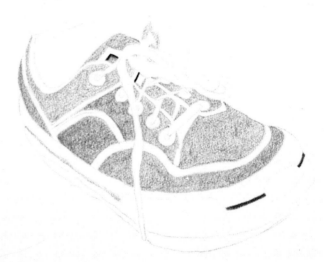

STEP 2: ADD COLOR

Try to avoid only using greys. Introduce a bit of color to the lighter darks with Clay Rose and Greyed Lavender, with a very light touch (1 pressure).

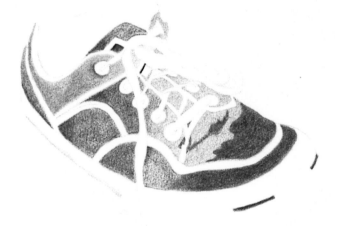

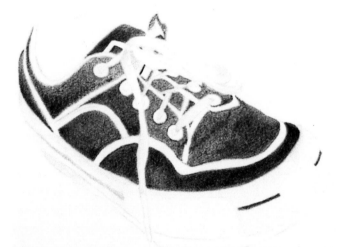

STEP 3: DARKEN THE COLOR

In the darkest areas (these tennis shoes appear to be wet, which is why some areas are so much darker), layer Indigo Blue with a sharp point, a smooth stroke, and a varied pressure (1 to 3). Next, cover the Clay Rose areas with French Grey 50% and 70% using smooth strokes (2–3 pressure).

STEP 4: DARKEN THE TONES

The Indigo Blue makes a nice undertone for the dark areas, but take it down with a French Grey 70%, followed by Cool Grey 90% over most of the darker area. Continue with the smooth stroke, and vary your pressure (2 to 3).

Start modeling the laces a with a light layer of French Grey 20%, adding a bit to the rubber sides of the shoe.

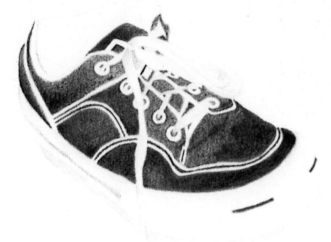

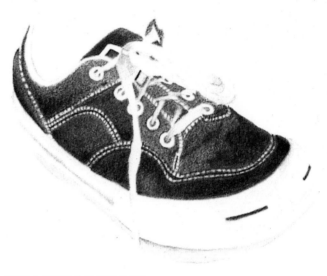

STEP 5: BEGIN THE DETAIL WORK

The last coat over the darker areas is a Cool Grey 90% (3–5 pressure). Begin work on the stitching by drawing a thin line in the white strip using a sharp Cool Grey 90% (3 pressure).

Add a little more grey to the sides of the shoe with another layer of French Grey 20%, then lightly layer Jasmine over some areas.

STEP 6: FINISHING TOUCHES

Using a very sharp Cool Grey 90%, break up the lines into stitches, then narrow the stripes here and there. Add bits of French and Cool Greys 50% on the darker areas of the laces and it's a wrap!

Teddy Bear

Painting stuffed animals can be relatively easy when you use the broken scribble stroke in a directional manner, following the direction of the fur, as long as you don't get too caught up in trying to follow every little tuft of fur in your reference photo!

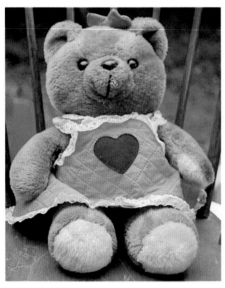

Reference Photo

Colored Pencils

Black
Beige
Blush Pink
Burnt Ochre
Carmine Red
Copenhagen Blue
Cloud Blue
Cream
Crimson Red
Dark Umber
Deco Pink
French Grey 20%
Indigo Blue
Jasmine
Light Umber
Marine Green
Poppy Red
Rosy Beige
Violet Blue
Warm Grey 70%
Ultramarine
White
Yellow Ochre

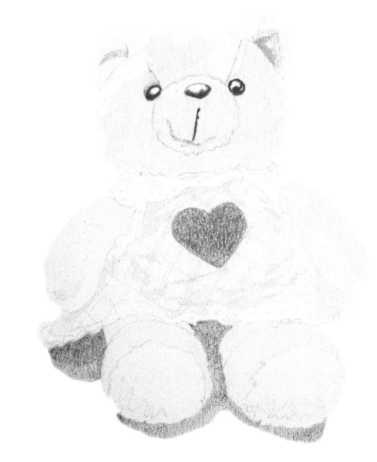

STEP 1: WASHES

Beige is the perfect color for the wash of the highlighted fur; start with a smooth stroke, 1 pressure in the highlights and a 2 pressure for the rest of the fur. Wash the paws with a light coat of Cream.

Start the eyes with Indigo Blue (4 pressure). Go heavy from the start (except a softening on the upper edge of the nose) since you will want to burnish the hard, shiny eyes. Wash the heart with Copenhagen Blue (1.5 pressure), using a scribble stroke, then move to her dress. Draw fairly wide stripes on the diagonal quilted pattern. This will define your "system." Look at the photo closely; you will see that the quilted diagonal stitching has a dark edge on one side and a series of tiny puckers on the right. The fabric between the puckers looks lighter than the rest of the fabric. Leave a stripe for the line, the puckers and the lighter area, which you'll fill in later. That is the "system" for this quilted fabric. You're looking for the essence of a particular texture or pattern and reducing it to the simplest possible method for achieving that look. Wash the fabric with Deco Pink using a smooth stroke on the shadowed areas (2 pressure) and on lighter areas (1 pressure).

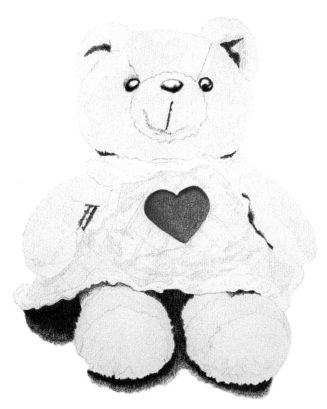

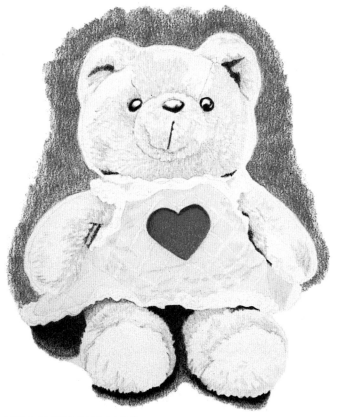

STEP 2: ESTABLISH THE DARKS

Establish some darks by outlining the edges of the shadow around the legs with Warm Grey 70%, breaking up the line to indicate the texture of fur. Next, fill in the outer edges (1 pressure) and the inner shadows (3 pressure) using a slightly dull point and a scribble stroke. Cover this with a very sharp Dark Umber, switching to a smooth stroke. You really want to fill the tooth of the paper in the darker shadows, so use a very sharp pencil here.

Next, apply a light (1 pressure) coat of Violet Blue to the heart; outline the heart first so you don't stray out of the lines. Use a sharp point and a smooth stroke for even coverage. Moving up, burnish her eyes and lower edge of her nose with Black. Fill in the darkest areas of fur with Dark Umber (3 pressure). Make sure your edges are very uneven to help create that furry texture.

STEP 3: DEEPEN THE DARKS

Finish the darkest shadows with Black, using a very sharp point ranging from heavy (5 pressure) in the inner areas to light (2 pressure) on the outer edges. With a slightly dull (so the underlayer will partially show through) Copenhagen Blue cover the heart (2 pressure). The red of her dress is more pink than orange, so layer Blush Pink, varying the pressure (1 to 3), but don't cover inside the stripes yet.

Although a pinkish hue may seem like a strange choice for the next layer of fur, when you look closely at the brown fur (with a value viewer, or course!) you see a definite pink undertone. Rosy Beige is a dull, greyed pink, perfect for the next layer on the non-highlighted fur. Use a broken scribble stroke directionally, following the direction of the fur. (Remember, the broken scribble stroke is one long continuous stroke, not choppy, separated strokes.) Vary the pressure to start modeling. Also begin modeling the paws with Jasmine.

The outer edges of the bear won't show up against the white background, so scribble Marine Green (2.5 pressure) around the bear leaving a narrow rim around the teddy uncovered with the Marine Green. Why leave a halo around the bear? Right now, the idea is to simply get in a quick background. Later, you'll concentrate on how the two edges—bear and background—meet.

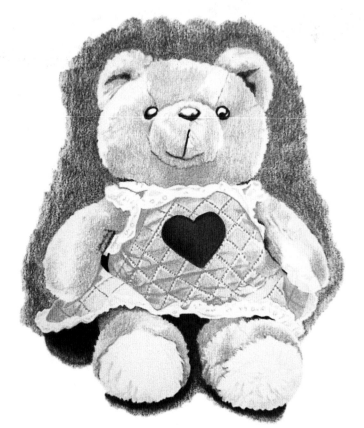

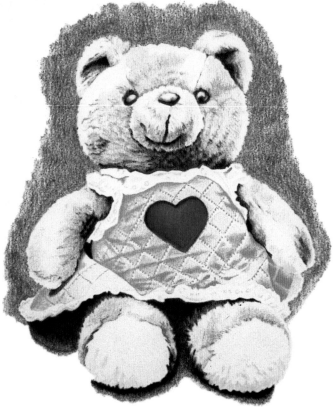

STEP 4: DARKEN THE COLOR

Using the value viewer, you will see that there's a lot of pink in the fur, so layer Blush Pink (2 pressure) over most of the fur (except the highlights) using a scribble stroke. This is going to make the previous layer of texturing practically useless, but it can't be helped now! It would have been better to reverse these two steps, but sometimes it's hard to know which way to go first. Over the Blush Pink, layer Burnt Ochre with a dull point using a scribble stroke (1–3 pressure).

Give the heart a heavy coat of Ultramarine, then take it down a bit with a final layer of Indigo Blue. Darken the dress with Carmine Red. Darken the stitching puckers and shadowed folds (4 pressure) and layer Carmine Red with a light (1.5 pressure) smooth stroke over the entire dress except the light strips next to the stitching.

To fill in the background, use a sharp Marine Green to outline the teddy with a very irregular line, then fill in the space between the outline and the background you put in previously.

STEP 5: ADD TEXTURE

Start with a sharp Poppy Red to darken the shadows of the bear's dress (3 pressure). It is still not dark enough, so cover this layer with Crimson Red (4–5 pressure). Add a little Yellow Ochre to darken the paws, and then Dark Umber to darken the fur. Use a broken scribble stroke directionally with a heavy 4 to 5 pressure to darken and add texture to the darkest area of the fur; make sure you use a slightly dull point. Finish the heart by burnishing a touch of White over a bit of the upper area, then outline the upper edge with Black. Burnish the highlights in the eyes with Cloud Blue, blending and softening the edges of the previous Black layer.

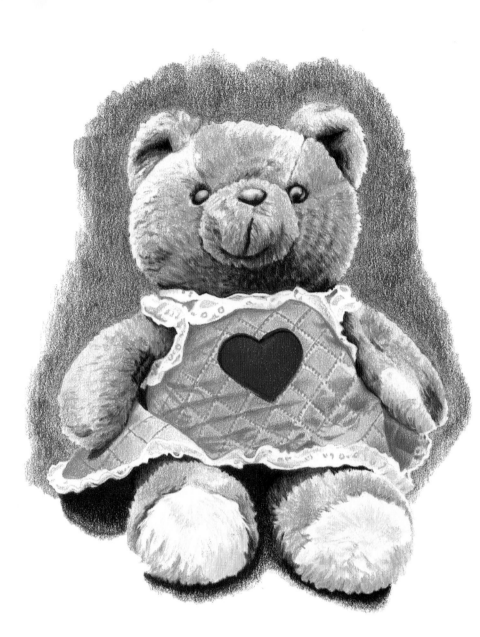

STEP 6: ADD DETAILS

Apply Rosy Beige to add texture to the mid-tone fur, varying the pressure from 1 to 3, using a directional broken scribble stroke. Look for patterns of shadows in the fur to try to duplicate the patterns without worrying about the exact placement of individual tufts. Use a fairly dull Burnt Ochre (1–3 pressure) to fill in some of the fur where it wasn't quite dark enough. Add a touch of Dark Umber to the darker parts of the fur. Use Rosy Beige for the darker fur in the paws followed by touches of Blush Pink and Yellow Ochre. Darken the light areas of the stitching slightly with Blush Pink. The final step is to lightly layer (1 pressure) French Grey 20% and Light Umber over darker portions of the lace to define some of the shadows.

Eyelet Lace

I think eyelet lace is one of the most rewarding fabrics to paint because it looks so detailed and seems that you must have spent hours on it, when it's actually very simple! Just be sure your eyelet holes are the same color and value of whatever is behind them (skin, fabric) and you're almost there!

Colored Pencils

Black Cherry
Blue Slate
Clay Rose
Cloud Blue
Cream
Cool Grey 10%
Cool Grey 50%
Dark Green
French Grey 20%
French Grey 50%
Greyed Lavender
Jasmine
Light Peach
Slate Grey
Warm Grey 10%
Warm Grey 30%

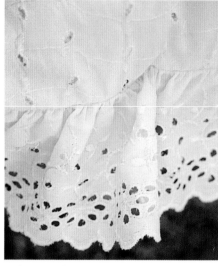

Reference Photo

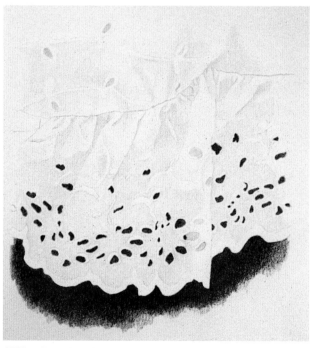

STEP 1: FIND THE SYSTEM

Eyelet lace has a straightforward system made up of four parts: holes, stitching, folds and puckers. If you pay attention to value, you'll see that the stitched areas are lighter, as are the folds where the fabric is doubled, while puckered areas are darker. Other than the eyelets themselves, that's all there is to the system! Start with a background of Dark Green, first outlining the holes and edges with a sharp point to keep the edges clean. Add Black Cherry, again outlining the edges first. Use a scribble stroke for both of these layers.

Use French Grey 20% and a light pressure inside the holes that cover fabric. Using Jasmine, lightly outline the seam between the ruffle and the pillow. Wash all areas that are not truly white (like the stitching) with Cool Grey 10% (0–2 pressure). Use a smooth stroke to avoid overlapping areas on this smooth fabric.

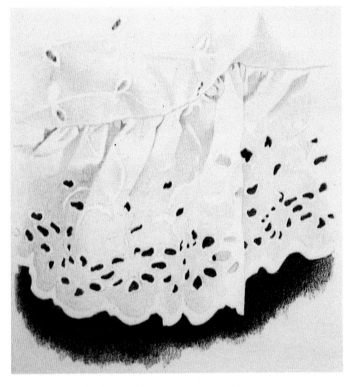

After the wash and darks are in, move to the next darkest areas. There is an undertone of lavender in the folds on the left. Greyed Lavender is the right hue but is too dark a value at this stage. Use combined layers of Cloud Blue and Light Peach (2 pressure), both of which are lighter in value. It is better to build value slowly, especially when working on white fabric. After the Light Peach and Cloud Blue, add a coat of Greyed Lavender using a smooth stroke (2 pressure). Darken some of the puckers using a very sharp Clay Rose (2 pressure) in a few puckers and in the holes of the upper section.

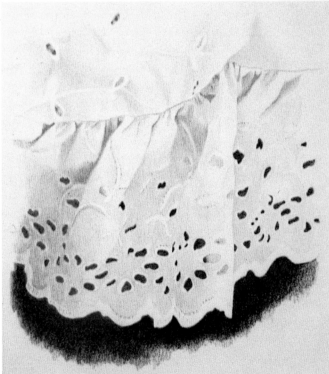

STEP 3: DARKEN THE SHADOWS

Darken the shadows using Slate Grey. Then use French Grey 50% in the darkest areas, varying your pressure from 0 to 2. Add just a whisper of Blue Slate to the midtone shadows.

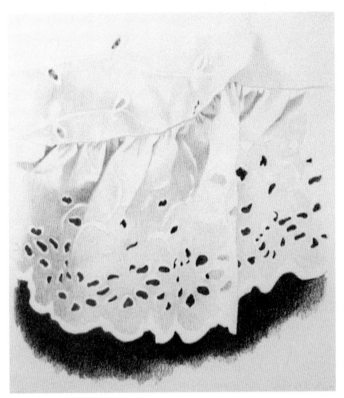

STEP 4: FINISHING TOUCHES

These last touches are little changes, but they make a difference. Cover some of the lighter areas with a Warm Grey 10%. Darken the edges of some of the stitching with Cool Grey 50%. Add a few needle holes around some of the decorative stitching with the Cool Grey. Darken the lighter stitched areas on the shadow side using a Warm Grey 30%. They will correspond to the darkening of the cloth around them and make this section look natural. Use a hint of Cream and Light Peach to the right of the larger fold.

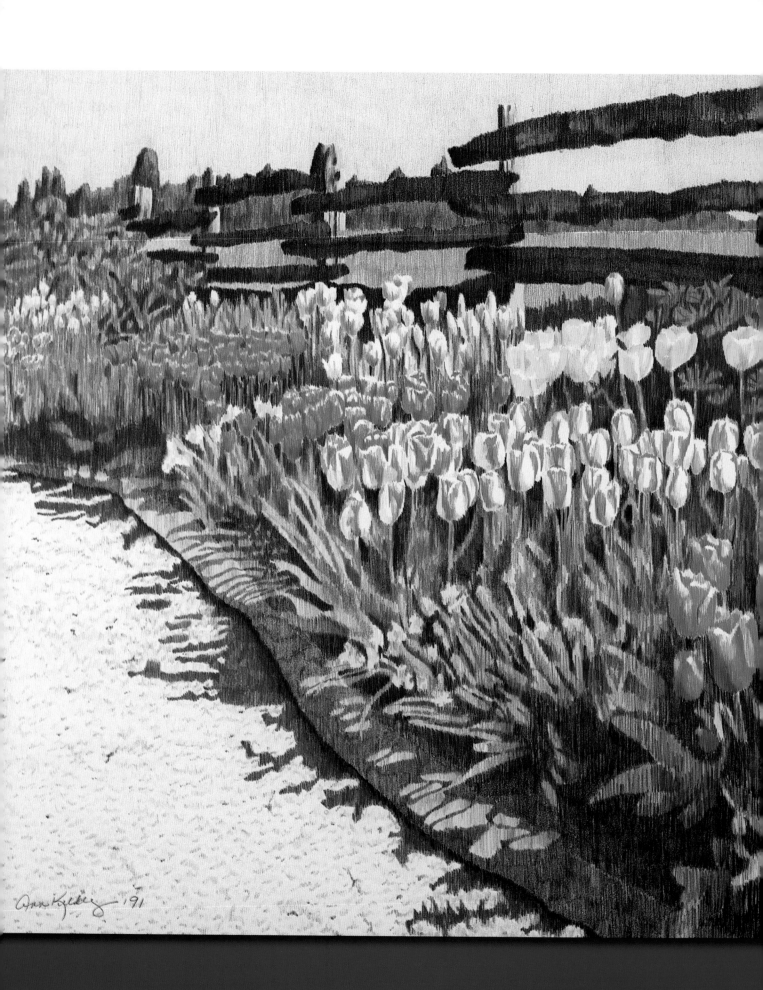

Ann Kjellberg '91

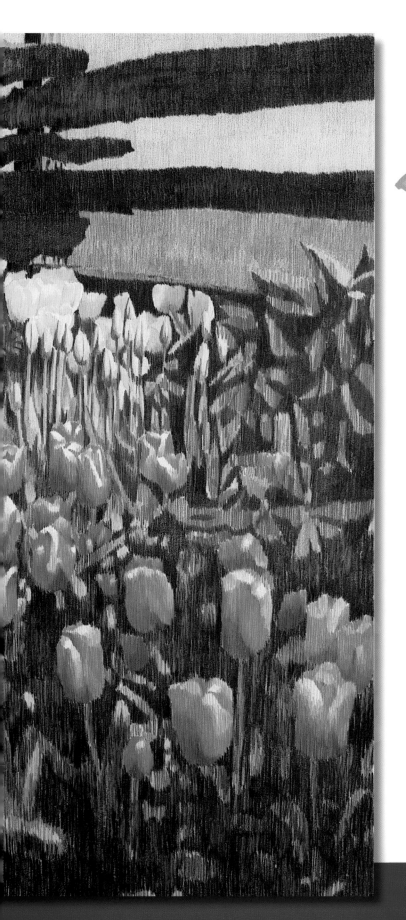

Exteriors

As soon as I began thinking about the possible demonstrations I might include in this section, I knew that Exteriors could easily be a book in and of itself! So my goal was to choose subjects varied enough to give you an idea of how I choose colors, how I build layers, how I apply the strokes and how I choose where to start rendering a particular subject. I've included calm and rough water, flowers near and far, new brick and old, and a host of other subjects. Though certainly not exhaustive, I hope it's a broad enough sample to get you started. My goal is to show you how I make complicated textures into simpler shapes and how I choose what detail to leave in, and what to leave out.

Spring Profusion
21" x 27" (53cm x 69cm)
Collection of Mrs. Florence
Larson

Apple Blossoms and Sky

This is probably my favorite demonstration in this book. Why? I love the simplicity of small blossoms like this, and I love watching whites begin to glow when the background starts getting darker. This is also a good demonstration to show how I build up whites. Whether painting apple blossoms or white clothing, you always want to add color to greys in order to give them life. Too often I see shadowed whites built up with grey tones alone, which never looks natural and always seems a bit flat and lifeless. Adding even a soft hint of pastel to greys will really add realism and interest to your white flowers, clothing or clouds!

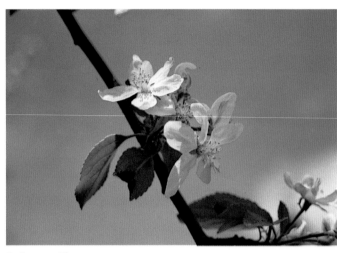

Reference Photo

Colored Pencils

Apple Green
Black
Blush Pink
Chartreuse
Cloud Blue
Dark Green
Deco Pink
Deco Yellow
French Grey 20%
French Grey 30%
French Grey 70%
Goldenrod
Light Peach
Limepeel
Marine Green
Non-Photo Blue
Olive Green
Pale Vermilion
Peach
Pink Rose
Spring Green
Yellow Ochre

STEP 1: WASHES

Although this branch will be a very brownish color, using browns alone will leave this twig looking flat, dull and lifeless. Begin with a wash of Marine Green (2 pressure) using a sharp point. Outline the branch before filling it in to achieve a very clean edge so the branch will come forward from the background sky.

Begin the sky with a light layer of Cloud Blue using a sharp point and the smooth vertical line technique (1.5 pressure). Try to avoid adding any texture by keeping the point, pressure and stroke consistent. Turn your pencil often to keep it sharp, and sharpen it after every dozen strokes or so. Immediately follow this layer with a layer of Non-Photo Blue applied in the same way as the Cloud Blue.

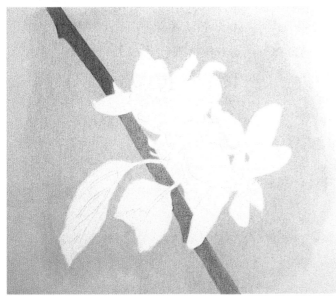

STEP 2: CREATE A WARM BASE

Again, you want to make sure this branch isn't dull and has a warm feel to the brown, so layer Goldenrod (3 pressure) to create a solid, warm base. Add one more layer of Marine Green (3 pressure), making sure that your point is sharp and that you outline the branch before filling it in. (In this example, only the top of the branch is covered with Marine Green, so you can see both layers.)

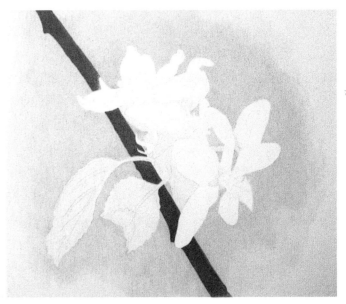

STEP 3: BUILD THE VALUE

Cover the branch with French Grey 70% (3.5 pressure) using a sharp point. Although the temptation may be to work in a directional manner on the branch, stick with vertical lines, which will give it a solid fill.

Next, darken the sky with Cloud Blue and Non-Photo Blue. Continue to use sharp points and the smooth vertical lines, increasing your pressure to a 2.

Wash the leaves with a light coat of Deco Yellow, using a sharp point and a smooth vertical stroke.

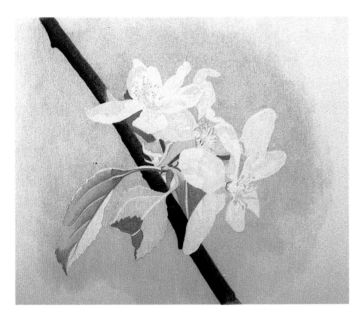

STEP 4: FINISHING THE DARKS AND BEGINNING THE LIGHTS

Finish the branch by adding Black (4 pressure) only on the left side of the branch to keep it from looking too flat. Use Limepeel over the Deco Yellow on all the leaves except for the one on the far left. On that one, use Chartreuse instead, since it's a yellower, brighter leaf. Don't cover the major leaf veins with these layers. Over these layers, use Olive Green and Dark Green, varying the pressure from 1 to 3 to begin establishing the darker values. Use a bit of Apple Green on the far left leaf.

On the blossoms, use French Grey 20% very lightly (1.5 pressure) and smoothly, followed by a light coat of Light Peach to add a hint of pink to the shadows. A few areas also get a touch of Deco Pink (1.5 pressure)—you can see pinkish greys in the reference photo. Last, the stamens are drawn in with Deco Yellow (3 pressure) and the tips are laid in with Peach.

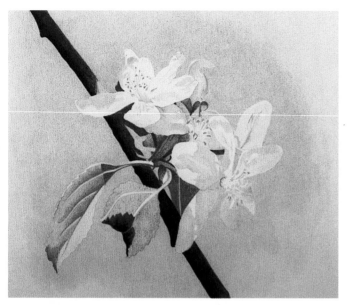

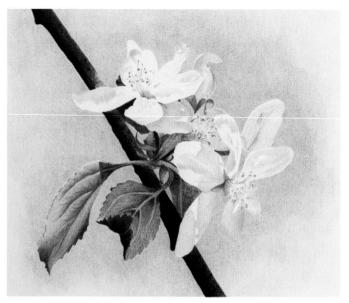

STEP 5: BUILD THE PETAL SHADOWS AND LEAVES

STEP 6: FINISHING TOUCHES

Darken the leaves with Dark Green and Black in some areas; varying your pressure from 2 to 3 in the darkest areas and keeping your pencil point sharp to get dense, even coverage. Add a light layer of Goldenrod to the light half of the far left leaf.

With the leaves nearly completed, you now need to get some of these "white" petals dark enough! It's not easy, since your brain keeps telling you these are whites and you may not want to pick up grey pencils to render them. But these blossoms will not look like they're in the sun unless you get some decent shadows in. So use Pink Rose, Blush Pink and French Grey 30% to slowly and carefully build up the shadows, using a smooth vertical stroke and varied pressure (1–3 pressure). Next, add Pale Vermilion to the tips of the stamens for added contrast and the blossoms are done!

This last step is always the hardest to explain. It is so much a touch of this, a touch of that, using a handful of greens and yellows—Chartreuse, Marine Green, Limepeel, Yellow Ochre and Spring Green. Add color to the veins, and to the leaves, allowing the veins to stay lighter. Darkening either side of the veins helps to give them a bit of depth. As a final touch, add the tiniest hint of Pale Vermilion to the light upper edge of the far left leaf with a needle-sharp point.

Q & A

Q: Why do darker streaks appear every so often when trying to render smooth areas like this sky background?

A: You're letting your pencil get too dull before sharpening. When you do sharpen, your point gets into all the valleys of the paper tooth, creating a darker line that looks like a streak.

Tulips

I thought it would be interesting to show how I create the look of tulips that are both close and distant in this demonstration. You'll notice that it's not until the last step that the blurred look of the far tulips is established. I hope this demo is useful in showing you how to create dense, dark, rich background foliage without actually drawing foliage!

Colored Pencils

Apple Green
Blush Pink
Crimson Red
Dark Green
Deco Pink
Deco Yellow
Grass Green
Indigo Blue
Non-Photo Blue
Olive Green
Pale Vermilion
Peacock Green
Pink
Pink Rose
Scarlet Lake
Terra Cotta

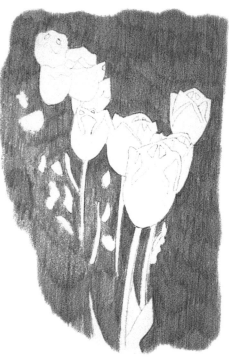

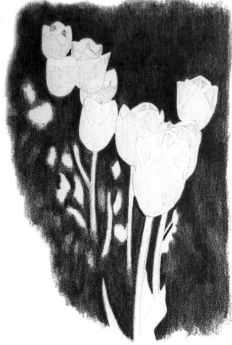

STEP 1: BEGIN THE BACKGROUND

Begin this painting by outlining the tulips and stems with a sharp Grass Green. If you don't outline them, you're likely to go into their borders with your quick wash. You also want them to come forward, in front of the dark green background. Keeping crisp, clean edges will bring the tulips forward. Next, lay in a quick wash of Grass Green (1.5 pressure) using a loose scribble stroke and a slightly dull point.

STEP 2: DARKEN THE BACKGROUND

Break up this flat area by applying two separate layers of Dark Green. The first layer is an all over wash (2 pressure). Cover the background again, this time varying the pressure (2–4). By covering some areas lightly, some heavily, and leaving some areas untouched, you start to create a mottled feeling of depth with only two colors. Remember to outline the tulips with a sharp Dark Green first!

The red of these tulips is on the pink side, so begin the tulips with a light wash of Blush Pink, as opposed to an orange-red. Use the vertical smooth stroke to keep texture down to a minimum.

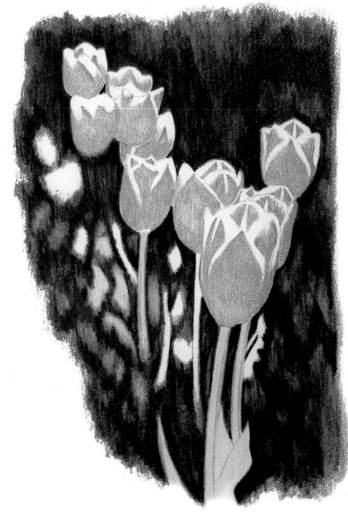

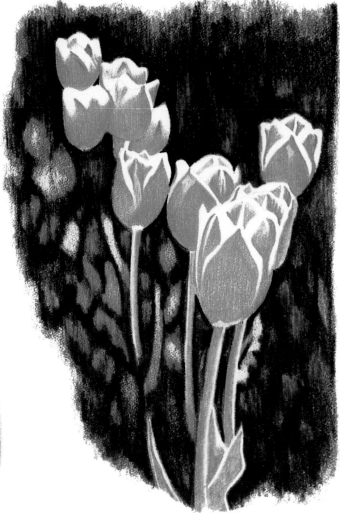

STEP 3: FINISH THE DARKS AND BUILD COLOR

Apply Indigo Blue with a slightly dull point (3–4 pressure) here and there to finish up the darkest areas of the background. Still working in the background, use Deco Yellow on the stems and a few of the lighter areas.

The next layer for the tulips is Pink using medium pressure with a soft vertical stroke, leaving the whites uncovered.

STEP 4: BEGIN MODELING

With a little Apple Green (3 pressure), begin to model the stems and leaves, leaving the edges uncovered, using a vertical line stroke. Use the same color in the lighter background areas but use a heavier pressure, especially around the edges of these lighter shapes, to help blend them into the darker background.

Add Scarlet Lake to the tulips. This is the first layer where any real attention is paid to detail on the tulips, leaving some areas uncovered so the previous pink layers show through. Most of the flowers are covered with a 3 pressure, increased to a 4 in some of the darker, denser areas.

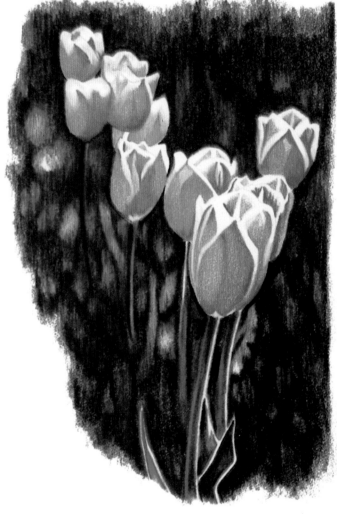

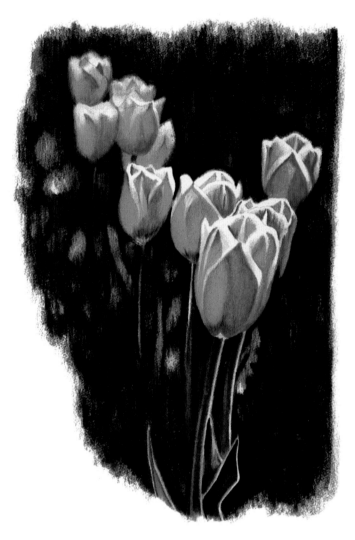

STEP 5: ADD MORE DETAIL

Darken the stems and leaves with Olive Green and Dark Green (4 pressure) using a very sharp point to create density and a smooth look. Be very careful not to lose the highlights because without them the stems and leaves will look flat. Darken the edge right next to the highlight. The background is too light, warm and busy, so with Non-Photo Blue and Peacock Green, darken the lighter areas, blending them into the background.

Use Terra Cotta (3–4 pressure) to create shadows on the tulips. Use a fairly heavy pressure because there is quite a buildup of color and wax by this point. However, the outer edges of these shadows are applied with a very light touch so the shadows don't look sculpted. In other words, work into the shadows with a light touch to start with before getting to the 3 or 4 pressure. Next, begin to blur the edges of the far tulips by applying a heavy layer of Deco Pink to just the outer edges. Leave the white areas untouched.

STEP 6: FINISHING TOUCHES

The tulips are a little too airy (too much paper surface showing, too little density) so burnish the lighter areas with Pale Vermilion and the darker areas with Crimson Red. Next, further blur the far tulips by going slightly into the edges with Olive Green, then burnishing with Deco Pink. Finish using Deco Pink and Pink Rose to add bits of shadow to the white edges of the tulips.

Distant Flowers

I won't lie—distant foliage can sometimes be a bit tough. This one took a bit of patience and careful concentration in order not to lose the fine, thin stems. The main thing to remember, though, is to study your photo reference to get a feel for the dark and light shapes, and a feel for the texture of the leaves and shapes. Then try to represent that feel rather than trying to follow every leaf, stem and shadow.

Reference Photo

Colored Pencils

Apple Green
Black
Canary Yellow
Celadon Green
Dark Green
Deco Yellow
Grass Green
Lilac
Olive Green
Pink
Spring Green

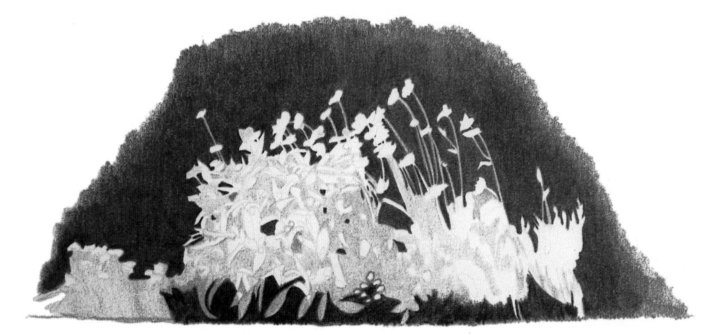

STEP 1: BACKGROUND

The first step is to fill in the background. With a very sharp Dark Green, then Black, carefully outline the stems, flowers and leaves, then fill in the rest of the background with a vertical line stroke (4 pressure). Once this background is in, throw a little Pink on the flowers that will be purple, then wash the foliage that will be darkest with Apple Green using a sharp point (2 pressure).

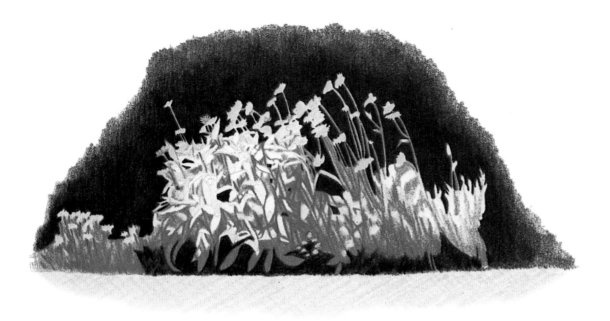

STEP 2: DEFINE THE SHAPES

With Grass Green, vary your pressure from light to medium. Fill in all but the lightest shapes using directional lines. Notice that although most of the lines slant towards the left, they are occasionally crossed with right diagonal lines. Next, fill in the flowers with Canary Yellow (3 pressure). You need a sharp point with these because they're so small! Add a bit of Lilac to the purple flowers and fill in a few of the warmer leaf shapes with Deco Yellow.

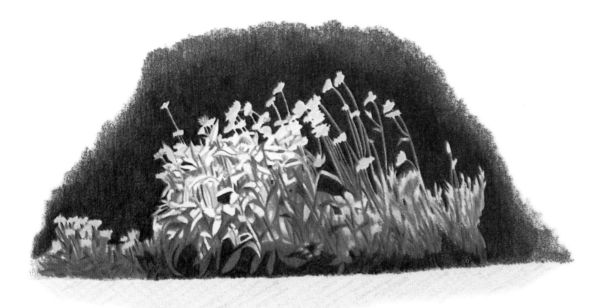

STEP 3: FINISHING TOUCHES

Use Dark Green on much of the foliage here to darken and to create smaller shapes from the larger shapes created in Step 2. Switch to Celadon Green and Olive Green for the foliage on the right side, then use Spring Green over the Deco Yellow of the warmer, lighter-valued leaves. Leave some areas white to accentuate the feeling of bright sunlight on the flowers.

Rhododendrons, Using a Marker Blender

There's nothing I love to paint more than a piece like this with such high contrast! These beautiful white rhododendrons against their own dark, lush background are so captivating to me. I couldn't wait to get started. One way to really bring out the bright white of these flowers is to make sure the background is very dark—bright whites will really sing next to deep, rich darks.

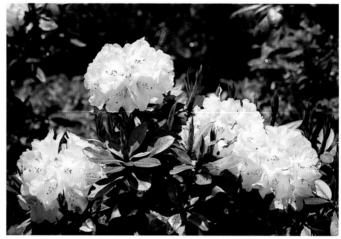

Reference Photo

Colored Pencils

Apple Green
Black
Burnt Ochre
Celadon Green
Cloud Blue
Cool Grey 50%
Cream
Dark Green
Deco Yellow
Deco Pink
French Grey 10%
French Grey 20%
Jasmine
Limepeel
Mineral Orange
Olive Green
Pale Vermilion
Pumpkin Orange
Scarlet Red
Tuscan Red

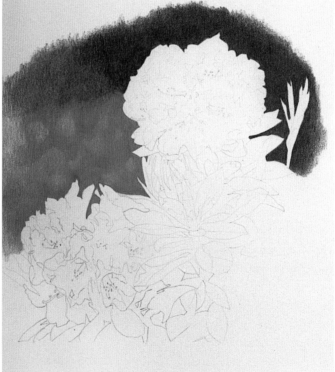

STEP 1: BACKGROUND

The flowers should have crisp, clean edges, so use a sharp Dark Green to outline the rhododendrons, except on the lighter bottom left, where you switch to an Olive Green for the outlining. This background needs to be dense, rich and very dark but you also want to do it quickly. So with a heavy (4 pressure) scribble stroke, using a sharp point, fill in the upper dark background. Switch to Apple Green for the lower section. Next, apply Tuscan Red (4 pressure) over the Dark Green and Olive Green over the Apple Green. Randomly create a few lighter and darker patches when applying the Olive Green by varying the pressure (2–4).

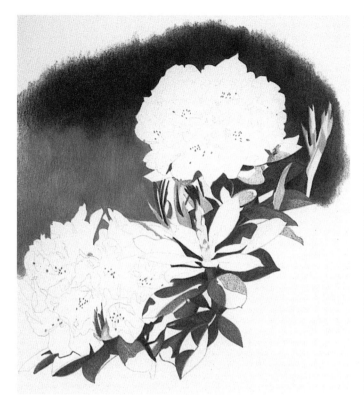

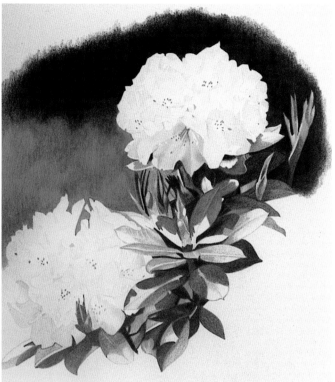

STEP 2: BLENDING

STEP 3: DETAIL AND SHADOWS

To get very dense coverage (no paper showing), use a Prismacolor Clear Marker Blender over the background. This is not the colored pencil colorless blender but an actual marker with both fine and broad tips. This marker blender is excellent because you have to use very little pressure to blend, unlike other colored pencil blenders. You want a fairly heavy cover of pencil before using the marker blender or your paper will buckle slightly and the colors won't actually blend. But the two heavy coats of Dark Green and Tuscan Red provide enough waxy protection that it blends beautifully. Use the fine tip around the flower edges and the broad tip over the rest. This entire process of blending should take less than four minutes and takes no pressure at all.

With the background in, start on the leaves. Use Pale Vermilion on the new growth, with a light pressure, sharp point and a smooth stroke. The green leaves receive a layer of Dark Green. Vary the pressure (1–3), depending on the value of each particular leaf.

Complete the darkest leaves with a fairly heavy layer of Black; vary the pressure somewhat to create distinction between the leaves. On the new-growth leaves, layer Pumpkin Orange (3 pressure) over the darker areas and then use the same color for the tips of the stamens.

The background could use just a little more depth, so very quickly and loosely scribble in more Tuscan Red and Dark Green using heavy pressure. Continue to add color in the lighter area but with a much lighter pressure; use Dark Green in the lower section only.

On the very lightest leaves, use Celadon Green to begin modeling. On the warmer (more yellow) leaves, layer Limepeel followed by Apple Green and vary the pressure as needed. Shape the new-growth leaves with Burnt Ochre and Olive Green; pay close attention to the photo reference to make sure you leave the highlights. If you lose the highlights, these leaves could end up looking flat. Add a hint of Jasmine over the center of some of the warmer leaves.

It's time to start modeling the rhododendron petals by putting in the shadows. Begin with a layer of French Grey 10% over all the shadow areas, then French Grey 20% in the darker shadows. Vary your pressure but keep your pencil point sharp and use a smooth vertical line stroke to keep texture to a minimum. Use Deco Yellow (3 pressure) for the stamens. (Notice one section of the upper rhododendron is nearly complete. I often choose a small area like this and complete it before moving on. It helps to give me a sense of where I'm going, and, in case I'm not going in the right direction, at least it's only a small area I need to fix rather than the whole flower!)

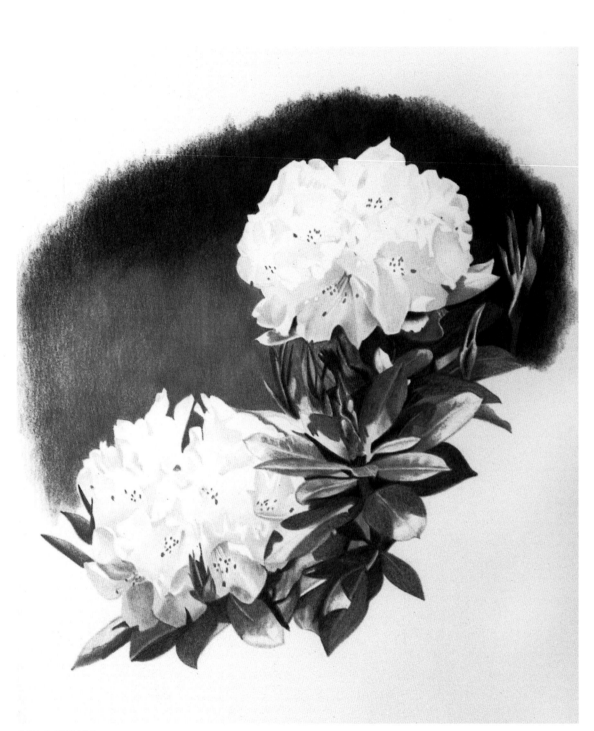

STEP 4: DETAILS

Darken the stamens with Mineral Orange, then use touches of Scarlet Red on small sections of the new-growth leaves to brighten them. Make them quite bright to help make them look translucent, as if the sun is glowing right through them. With a smooth stroke, add Deco Pink, Cream and Cloud Blue to much of the petal shadows, increasing and decreasing your pressure to create depth and value changes. Layer Cool Grey 50% in the darkest petals, using as much as a 3 pressure in some of the darkest areas. Finally, finish modeling the lighter leaves with Celadon Green and Apple Green.

Hedge, Sidewalk, Ivy and Background Greenery

This demonstration combines many different elements, showing you not only how I create the look of a hedge but also a sidewalk and greenery that is far in the distance. Although this is not the easiest thing to do in colored pencil, a hedge like this laurel is not actually as hard as it might seem, either. By paying attention to the outside edges and including the shapes of a few specific leaves, the sense of a hedge or bush is relatively easy to create. Sidewalks are a breeze and even far-off foliage is quite simple if broken down into large, loose shapes, as you'll see me do here.

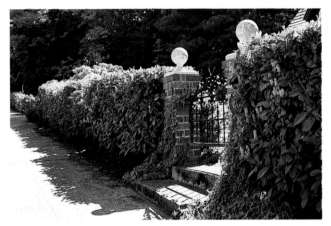

Reference Photo

STEP 1: WASHES

With so many elements in this demonstration, you need to get washes in throughout to get a sense of the overall piece. Several layers of color will follow so don't be particularly careful about your stroke or point. Start with Dark Green for the background greenery (1), being careful to outline the edges that meet the top of the hedge with a sharp point. These leaf shapes on the outer edge of the hedge are very important, so be careful not to lose those as you fill in the background. Fill in the lighter shapes in the background (2) with Spring Green. Use a loose scribble for this entire background area (3–4 pressure), except in the lighter spots.

Use Light Green for a light (1.5 pressure) wash on the hedge (3). This is just a quick wash, done with a slightly dull point and a loose scribble stroke. Wash the sidewalk (6) with Cool Grey 30% (2 pressure). Use Sepia for the shadow under the hedge (5) and then wash the bricks with Mineral Orange (4). Chartreuse is the first wash on the ivy (7); to finish, use Sienna Brown on the gate.

Colored Pencils

Apple Green
Black
Black Grape
Burnt Ochre
Chartreuse
Cool Grey 30%
Dark Green
Dark Umber
Deco Yellow
French Grey 50%
Grass Green
Indigo Blue
Light Green
Mediterranean Blue
Mineral Orange
Non-Photo Blue
Olive Green
Peacock Green
Pumpkin Orange
Sepia
Sienna Brown
Slate Grey
Spanish Orange
Spring Green
True Green
Tuscan Red

STEP 2: BUILD TEXTURE AND
BACKGROUND GREENERY

With heavy pressure (4) apply Indigo Blue to
the greenery (1), using a loose scribble stroke
to quickly bring these darks up. Build some
vague branch-like shapes by avoiding some
areas with the next two layers of Sepia and
Peacock Green. Apple Green and a bit of
Olive Green complete the area (2).

Move to the sidewalk (6) using a light (1.5
pressure) layer of Mediterranean Blue since
there is a fair amount of blue in the shadow
in the reference photo. Keep this layer rather
smooth, using a smooth vertical line stroke.
A layer of Pumpkin Orange goes over all the
bricks, followed by French Grey 50% over a
few of them, using a light touch but a slightly
dull point to add some texture. Tuscan Red
and Burnt Ochre go next over the gate,
leaving the white paper for the highlights.

You need a simple way to create the texture
of climbing ivy without actually drawing little
ivy leaves. Use Apple Green to make little
star-like squiggles over the Chartreuse, leaving

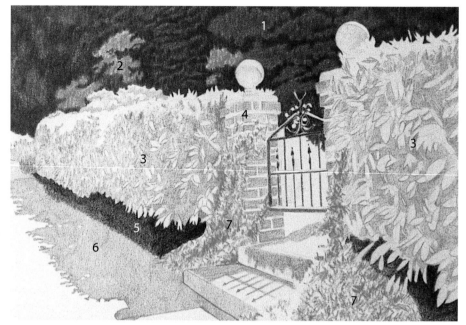

some areas uncovered and using more pres-
sure in some areas to build depth. On the
hedge shadow (5) apply a heavy layer of Black
after first carefully outlining the leaf shapes
along the upper edge.

Use Grass Green (2 pressure) to outline
some leaf shapes in the hedge (3). It's only

necessary to outline a few leaves and none at
all as the hedge gets farther away. If you make
a few leaf shapes, the viewer's mind will make
up the rest of the texture, and you save lots
of time! After outlining, fill in the hedge (3)
using a short scribble stroke, varying the
pressure (2–3) to create depth and texture.

STEP 3: DEFINE THE SHAPES AND
ADD COLOR

Finish the background area (1) by filling in
some of the lighter areas with both Light and
Spring Green, and in area (2) with Dark
Green here and there. Move to the hedge
shadow (5) to complete the darkest darks,
using Black with a heavy pressure and a sharp
point. Now darken the bricks (4) using Black
Grape (1–3 pressure) and Burnt Ochre. Add
the darker shadows on the sidewalk (6) with
Dark Umber using a directional, slightly hori-
zontal stroke. If you made these strokes round
instead of horizontal, the sidewalk would
appear to come up instead of lie flat.

In the hedge (3), use Dark Green, vary
your pressure (2–5) and break up the previous
Grass Green layer into smaller leaf-like shapes
to imply leaves and depth. Use Deco Yellow
on the sunlit spots and the flowers of the
hedge. Apply Light Green on the actual leaf

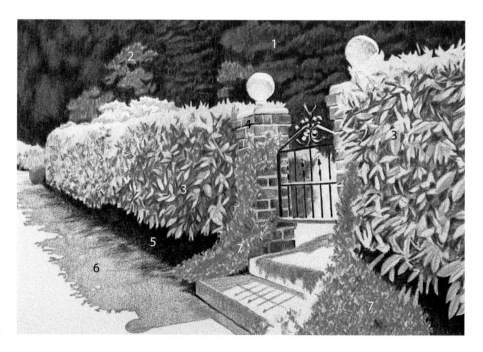

shapes and randomly toward the back of the
hedge. Using Grass Green with the same
squiggly star shape to add color to the ivy (7).

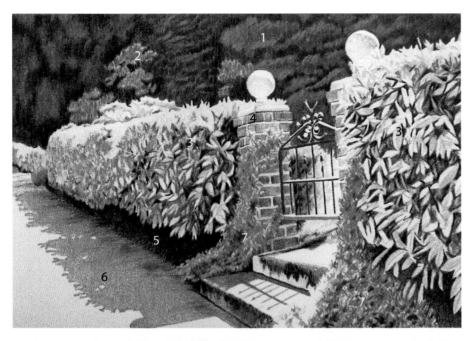

STEP 4: ADD DEPTH

Now finish the stairs and sidewalk (6) by adding touches of Black and Sepia, then soften those layers with Slate Grey (6). This softens them since it is a lighter value than the Black and Sepia layers.

The yellow hedge (3) highlights need to be broken up a little, so use Chartreuse randomly in leaf-like shapes. Create more depth to the nearer portions of the hedge by applying Black over some of the Dark Green areas. Add Spring Green in short, choppy strokes to the middle to back section of the hedge.

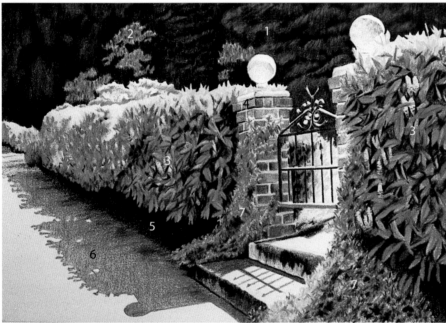

STEP 5: FINISHING TOUCHES

Just a few touches will wrap up this hedge (3)! Keep Grass Green, Dark Green, True Green and Non-Photo Blue in your left hand and add color to the leaves in a random manner. In other words, just grab a pencil out of your left hand and add touches of that color here and there, then take the next pencil and add more. Add another layer of Spring and Grass Green to the far hedge, and then with a bit of Spanish Orange, brighten up bits of the highlights on top. Voila! A laurel hedge without too much detail or pain!

Tall Grasses, Dirt and Beauty Bark

My best advice to you if you ever get the urge to draw a grassy shrub like this—get a new urge! I'm only partially kidding. This sort of grassy plant by far takes the most patience and road-mapping, but if you like drawing detail, you'll certainly like this demo!

Colored Pencils

Apple Green
Black
Blush Pink
Burnt Ochre
Chartreuse
Clay Rose
Dark Brown
Dark Green
Dark Umber
Goldenrod
Grass Green
Jasmine
Light Green
Light Umber
Limepeel
Olive Green
Rosy Beige
Sienna Brown
True Green
Yellow Ochre

Reference Photo

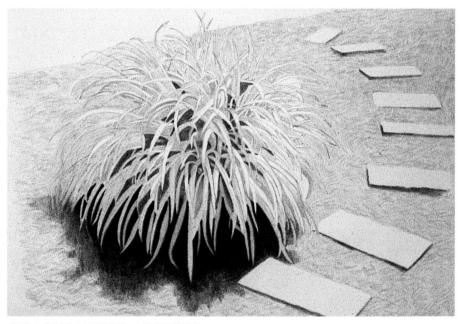

STEP 1: ROAD-MAPPING AND WASHES

Wash the dirt/beauty bark with a quick scribble layer of Rosy Beige (2 pressure) because there are pink undertones in the reference photo. Apply Clay Rose to add texture to the bark with short directional strokes in a very random fashion. Try to make these strokes close together and a little more horizontal as you move toward the back. If you make all these strokes exactly the same, front and back, the dirt will look like it's coming forward instead of laying flat. Fill in the shadows of the stepping stones with Clay Rose followed by Dark Umber (3–4 pressure).

You want a dark shadow under the bush, so with Burnt Ochre, Dark Green, Sienna Brown and Dark Umber, use a scribble stroke to build up this shadow. Why Dark Green? It seems like a nice addition since it's logical that the shadow may carry some of the local color of the bush. Next, painstakingly begin the road-mapping stage of finding the darkest darks in the bush. Use a heavy pressure and a sharp point to outline each dark shape, then fill it in with Dark Green and Black. Cover all but the lightest blades with Apple Green, varying your pressure (1–3). Cover a handful of the lighter blades with Jasmine instead of Apple Green.

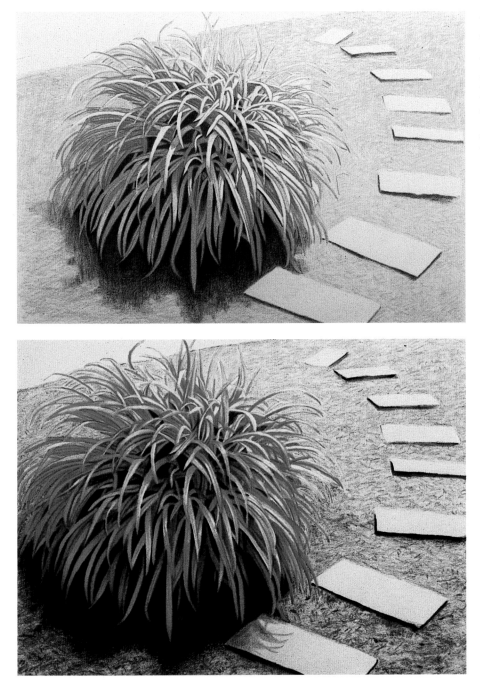

STEP 2: BUILD COLOR

Warm the left side of the bark with Jasmine, then Yellow Ochre, using a light to medium pressure and a quick scribble stroke. Next, with a handful of greens, add color blade by blade. (Which is why this isn't a particularly quick or easy bush to paint, because of the blade-by-blade technique!) Use Apple, Grass, Olive and Dark Green for this step. In a very few of the blades, use a sharp point to divide the blade down the middle and add touches of detail.

STEP 3: FINISHING TOUCHES

Darken the bark with Goldenrod, then Light Umber on the left side using a loose scribble stroke with medium pressure. Go over the entire ground with Light Umber, using short, directional texture strokes. Repeat this step on the warmer side only with Dark Brown and Dark Umber.

Now that the value of the dirt has been brought up, the shadow is too light, so with Black and Dark Umber use the scribble stroke to darken under the bush. Decrease your pressure as you come out of the shadow so the edges are soft.

You will need a handful of greens to darken and shape each blade. Use Light, Apple, Grass, True and Dark Green with sharp points (3–4 pressure). Notice how, on the lighter-valued blades, the center is left white or nearly white. This technique helps to make the blade appear to gently curl. Use a bit of Chartreuse and Limepeel on the yellowish blades. For a finishing touch, use Blush Pink then Clay Rose to fill in the shadow on the closest stepping stone.

Close Grass

This might be a little closer than you'll ever need to render grass, but the process is the same, even if you're a little further back! A few underlying washes, some very dark triangular shapes to add depth, and diagonal strokes pretty much do the trick. You can see how I render distant grass, or lawn, in the Fir Tree Trunk (page 92) and in Tropics (page 102).

Reference Photo

Colored Pencil

Dark Green
Deco Aqua
Grass Green
Olive Green
True Green

STEP 1: FIND THE DARKS

The first step is to find small, triangular shadow shapes that the crossing blades of grass create. Fill these with Dark Green using a sharp point and a heavy touch. (Don't get too carried away with these triangular shapes and don't feel you have to follow your reference photo too closely. Just add a few here and there where the grass is darkest or most shadowed.) Notice that in the graphite drawing there are very few details. You just want a few blades over the feet and a few triangular shadow shapes outlined or you'll become too meticulous about following the reference photo.

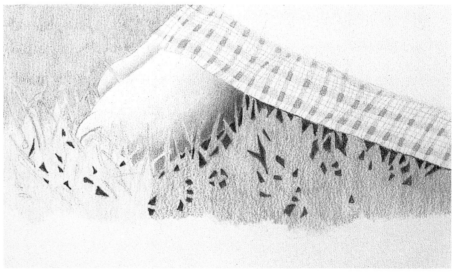

STEP 2: WASHES

This grass is on the cool side—bluish green as opposed to yellowish green—so first wash the entire area lightly with Deco Aqua, which is a cool green, using a slightly dull point and a scribble stroke. Wash the area with True Green, shown only partially completed on the right.

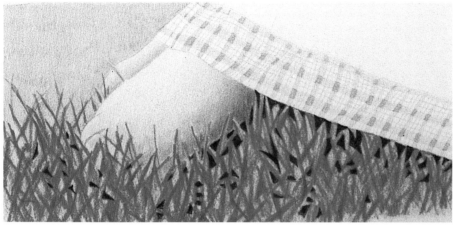

"Warm" Grass

If my reference photo had shown "warmer" grass, my first wash (Step 1) would have been Limepeel, and my first blades would have been Apple Green. In Step 2, I would have used Olive Green and Dark Green for darkening the blades, then filled in the light areas again with Limepeel.

STEP 3: ADD BLADES

Using a slightly dull Grass Green, randomly apply strokes of different widths and lengths, moving diagonally right and left, but allowing the tips of these strokes to get thinner. Use a 2 to 4 pressure on these blades, and make sure to leave some of the True Green showing through. Just these three layers already start to create the look of grass.

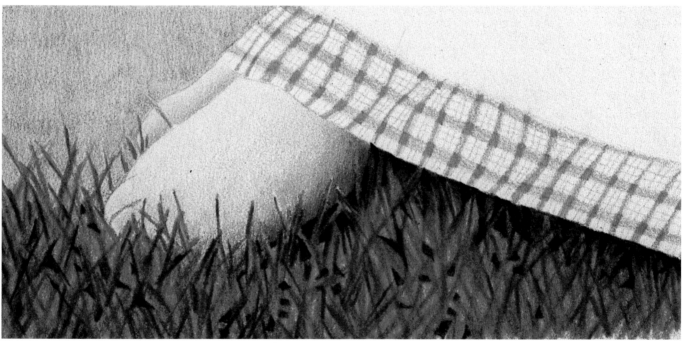

STEP 4: FINISHING TOUCHES

Use Olive Green and Dark Green and heavy pressure (4) and continue to add more blades and darken those already applied. Especially darken those under the skirt to give depth to the grass. Using True Green, darken the lighter areas that are peeking through the individual blades.

Fir Tree Trunk

The hardest part of painting a tree trunk like this fir tree is in the first step—the road-mapping. Following the reference photo carefully to find the darks can take a bit of time and patience, but once that's done, the rest is a breeze!

The background was completed before I began this demonstration, but I'll give you a brief overview of how I painted the grass and shrubs. I quickly washed in light layers of Jasmine then Limepeel over the entire grassy area, using a slightly dull point and a scribble stroke. I built up the shadow areas with very short, choppy scribble strokes using Olive, Marine and Dark Greens with some Black in the darkest areas. I finished the grass with Apple Green and Olive Green in the lighter areas with short, random, loose strokes. On the greenery above the fence I used loose, loopy strokes and a dull point to quickly add texture and depth. I started with light values, like Jasmine and Limepeel, and slowly moved up the value scale with both yellows (Yellow Ochre and Goldenrod) and greens, randomly applying them here and there. The darkest values I used in this area were Olive Green and Light Umber. The sky was quickly laid in with light layers of Cloud Blue then Deco Blue, and finally Blue Slate, all applied with a smooth vertical stroke and a sharp point.

Reference Photo

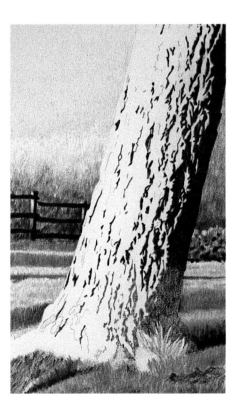

Colored Pencils

Apple Green
Black
Blue Slate
Burnt Ochre
Cloud Blue
Cool Grey 50%
Dark Green
Deco Blue
Goldenrod
Henna
Jasmine
Light Umber
Limepeel
Marine
Olive Green
Sepia
Terra Cotta
True Green
Tuscan Red
Yellow Ochre

STEP 1: ROAD-MAPPING

Begin the fir tree by finding the darkest darks. Use Tuscan Red, since it will add a deep, warm richness to the Black you'll add next. Use a medium pressure (3) for both the Tuscan Red and Black, keeping the point fairly sharp so you can get into many of the valleys of the paper surface, ensuring dense coverage. After the darks are in, lightly apply Yellow Ochre to a few of the warmer areas on the light side of the trunk.

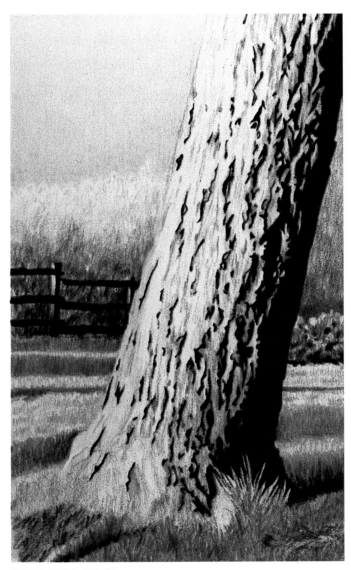

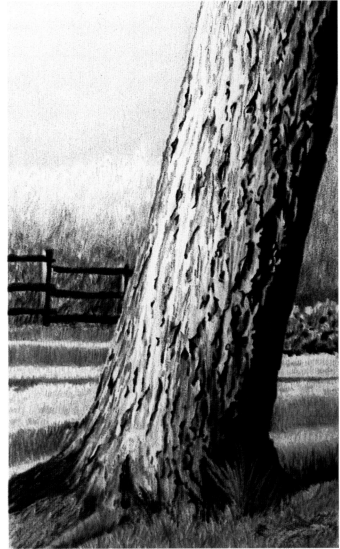

STEP 2: BUILD COLOR

STEP 3: TONE DOWN AND WARM UP

Add Burnt Ochre (3–4 pressure), loosely and randomly using a directional stroke and a slightly dull point. There is a fair amount of red in this trunk, so apply Henna arbitrarily in places that can use a bit of red. With Cool Grey 50%, cool down the bottom left highlighted area. In the reference photo, you can see some moss in this lower left area, so add a bit of True Green to these shapes.

Tone down some of the Burnt Ochre and continue to build texture with Light Umber, using a fairly sharp point, loose directional stroke and varied pressure. Use Jasmine and Goldenrod in the highlighted area closest to the shadow. These yellows help give the trunk the look of warm evening light. Sharpen and intensify some of the darks with Terra Cotta and Tuscan Red to really punch up the color and contrast. Darken the bottom left area with Sepia (which is a dull, greyish greenbrown) over the Cool Grey 50%, varying your stroke length and width and working with a fairly dull point.

Build up the moss with Limepeel, Olive Green and Dark Green. Notice that, although this trunk is now complete, a fair amount of pure, white paper remains visible on the highlighted half of this tree. This wide range of values (white paper to rich Black) imitates a strong light source.

Lake and Trees

Painting water in colored pencil may seem difficult, but still water like this lake is actually quite simple. Make sure your reflections truly reflect what's happening above the water line and you need to keep your ripple lines horizontal, but that's about it. Any reflections that are light in value are easily burnished with White over the top of darker colors, so that part's a snap!

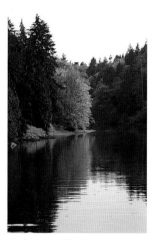

Reference Photo

Colored Pencils

Apple Green
Black
Celadon Green
Cloud Blue
Dark Green
Dark Umber
French Grey 30%
French Grey 70%
Indigo Blue
Jasmine
Light Umber
Limepeel
Marine Green
Olive Green
Peacock Green
Sepia
Spring Green
True Green

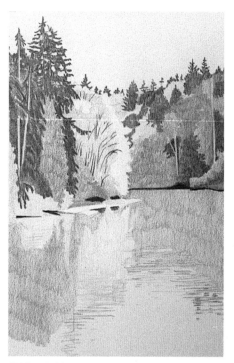

STEP 1: FIRST WASHES

Trees

Wash in the trees using just about every green available! Dark Green and Marine Green for the darkest trees, Olive Green, Peacock Green, True Green and Limepeel for the lighter trees. Use Jasmine to wash the very lightest trees. Vary your pressure (1–3) for these washes and using a loose scribble stroke and a dull point.

Water

Quickly wash the water with Olive Green and Jasmine, using a light touch, a slightly dull point and vertical line stroke, except for the ripples, which are drawn in horizontally using a sharper point.

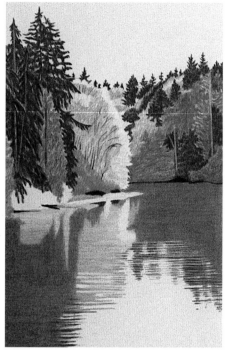

STEP 2: BUILD COLOR AND VALUE

Trees

Continue to build color and value in the trees using Indigo Blue, Black and Dark Green on the darkest trees and Marine, Olive, Apple and Celadon Greens on the lighter trees. Add a few trunk lines with Dark Umber.

Water

Build up the color very quickly with a medium layer (3 pressure) of Olive Green using a vertical line stroke followed by a layer of Dark Green. Use a 4 pressure with this last layer, using a sharp point and a smooth, horizontal stroke. Add Limepeel in the same manner over the previously applied Jasmine layer.

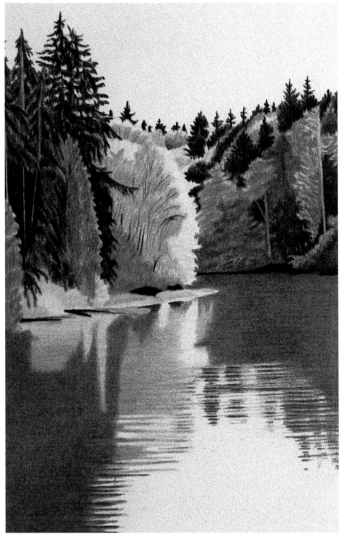

STEP 3: DARKEN THE TREES

Trees

Continue to darken the trees using Limepeel, Olive and Marine Greens with a little True Green on the bank. Tone down the lighter trees and the greenery around the bank with Celadon and Marine Green, and then pull all of the greenery together by applying Marine Green over the midtone trees.

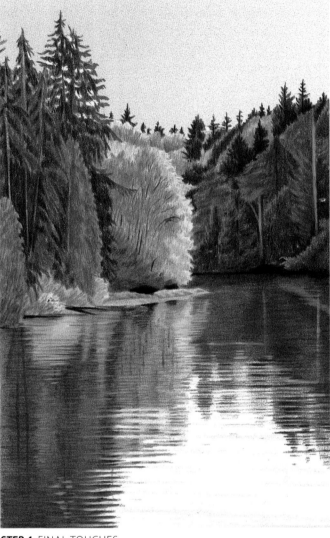

STEP 4: FINAL TOUCHES

Water

Use French Grey 30% to draw in the tree trunks on the right side plus a few horizontal ripple lines. With Dark Green, Peacock Green and Sepia, darken the water using sharp points and horizontal strokes. Draw a few horizontal strokes with Spring Green as a reflection for the lighter greenery above the bank. Add vertical strokes with Light Umber to serve as reflections of the tree trunks. Use Marine Green and a tiny bit of Dark Green horizontally across this lighter section of water. Also use a little True Green in the bank and the greenery near the bank. On the left side of the water, use French Grey 70% to add the tree trunk lines, then darken it with horizontal strokes of Sepia. Go into the yellowish section from either side with Apple, Marine and Sepia, using a sharp point. Use White to add a few light reflections in the water, then use Cloud Blue in sparse streaks in the section previously left white.

Alder Tree Trunk With Crosshatched Background

Besides showing you how I do this smooth sort of tree trunk, this is a perfect opportunity to demonstrate a quick crosshatched background. This quick method of applying color is perfect when you want a soft, ethereal backdrop or for vignettes. It is more interesting than a simple vertical line application.

Colored Pencils

Black
Blue Violet Lake
Blush Pink
Burnt Ochre
Celadon Green
Chartreuse
Cool Grey 30%
Dark Brown
Deco Yellow
French Grey 30%
French Grey 70%
Indigo Blue
Jasmine
Marine Green
Mineral Orange
Olive Green
Poppy Red
Rosy Beige
Salmon Pink
Spring Green
Warm Grey 30%
Warm Grey 70%
Yellowed Orange
White

Reference Photo

STEP 1: BURNISH THE TRUNK AND WASH THE BACKGROUND

Trunk
Be careful not to lose the small light splotches in the shadowed half of this alder trunk. Take a slightly dull White and nearly burnish many of the white spots of the trunk, applying it in a directional, horizontal stroke. Future layers will not cover these burnished white areas very well, so you're assured of keeping them. Cover the shadow side with Celadon Green, using a slightly dull point. Apply the green with a light touch so this layer just skips over the burnished white. The closer a shadow is to the object that casts it, the darker and sharper it is, so outline the darker shadows with a sharp point before filling these in.

Background
Use Blush Pink in a vertical line over the entire background (it's shown only partially done here), then cover the Blush Pink with Salmon Pink in a left diagonal stroke, letting your strokes be fairly wide-spaced so some of the Blush Pink layer shows through.

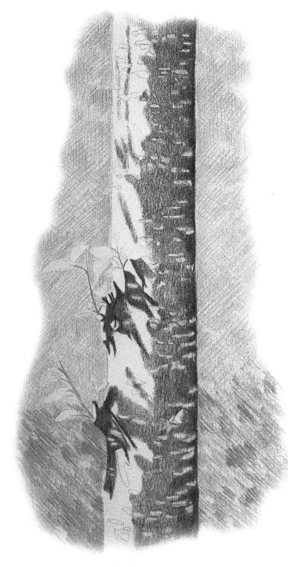

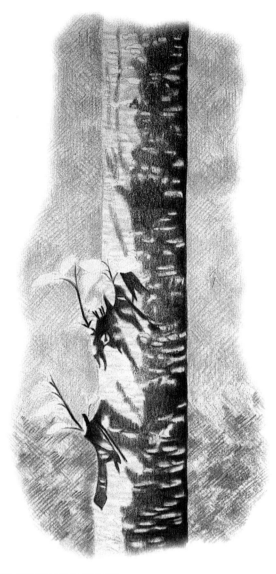

STEP 2: ESTABLISH THE DARKS

Trunk

Cover the shadow with a layer of French Grey 30%, followed by Olive Green, using a light pressure on the left but increasing to a 3 on the right, with a slightly dull point and a scribble stroke. The photograph shows the shadow undertones to be quite blue, but this is a warm palette, which is why you want a green here instead of a blue. Layer Deco Yellow in the leaves and Yellowed Orange in the young stems.

Background

Add Mineral Orange using a right diagonal stroke. Notice that the strokes are widely spaced to let the bottom two layers show through. Vary your pressure slightly in a random fashion to build depth. A left diagonal of Spring Green follows a vertical layer of Chartreuse for the grass.

STEP 3: DARKEN THE COLOR

Trunk

Darken the trunk with Warm Grey 70%, varying your pressure (2–4) using a slightly dull pencil and a scribble stroke. Use Indigo Blue to darken the trunk. With these last two layers, avoid the white blobs by working around them instead of going right over them.

Continue to scribble, working slightly directionally and applying your scribble strokes horizontally across the shadow. A touch of Poppy Red followed by Dark Brown finishes the new-growth stems. Layer a little Cool Grey 30% on the lighter side of the trunk in a horizontal, linear stroke, using a dull point and leaving some areas uncovered.

Background

Grey down and push back the background a little using Rosy Beige for the bricks and Marine Green for the grass.

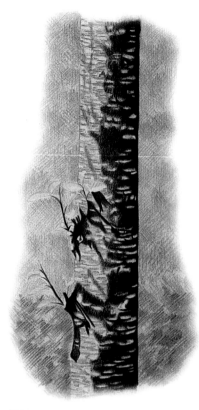

STEP 4: CREATE TEXTURE

Trunk

Over the Indigo, use Warm Grey 70% then Black, increasing your pressure from 2 on the left side to 5 on the right, still avoiding the white splotches. Apply Warm Grey 30% in a rough, random horizontal stroke to give more texture to the lighter, left side. With Chartreuse and Jasmine, add a bit of detail to the new leaves.

Q & A

Q: What do you mean by a warm palette?

A: Warm colors are those that lean toward the yellows and reds. Cool colors lean toward the blues and purples. I have a "warm palette" which means that even when I see cool colors, I tend to warm them up. In the reference photo for this demo, the shadows are quite cool; the greys are bluish grey. Since I naturally warm colors, I choose green (which is of course, blue with yellow added) as an undercolor to the greys, rather than blue.

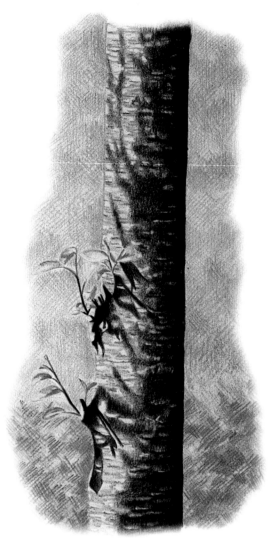

STEP 5: FINAL DETAILS

Trunk

Darken the light splotches on the right side with Blue Violet Lake then Warm Grey 70%. You need a fair amount of pressure for this, since that early coat of burnished White wants to resist further layers. Use French Grey 70% with a dull point, light pressure, and a soft, loose circular stroke to soften the hard edge where the shadow meets the highlight. Use Olive Green here and there on the new leaves and Burnt Ochre on the orange leaves.

Ocean and Clouds

If you live in the northwestern United States like I do, you'll see this sort of scene often—fir trees, mountains, water—and of course, clouds! Don't let reflected water scare you; it's really much easier than you think. The hardest part is making sure the reflections run horizontally without a diagonal bent. I see quite a few paintings in which the water horizon runs at a slight diagonal. This is a camera effect, so beware. If your photo reference shows the ocean at a slight tilt, straighten it out!

Colored Pencil

Black
Blue Violet Lake
Cloud Blue
Cool Grey 10%
Cool Grey 30%
Cool Grey 50%
Dark Green
French Grey 20%
French Grey 50%
French Grey 70%
French Grey 90%
Marine Green
Periwinkle
Yellow Ochre

Reference Photo

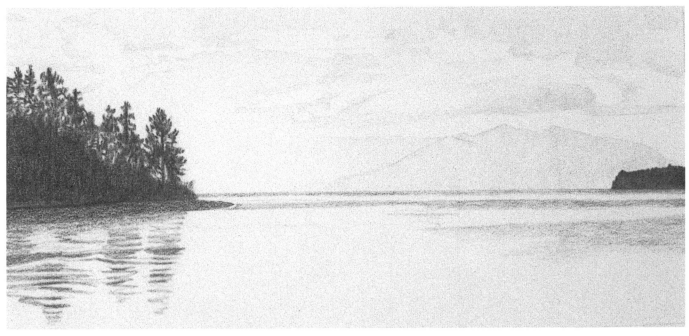

STEP 1: WASHES

You want to establish the darks first. Using a scribble stroke (3 pressure), lay in the nearer hills with Dark Green. Using the same color, but a directional stroke, start to draw in the tree shapes. With a very light pressure (0.5–1), add Cool Grey 50% in the darkest areas of the water. Wash the darkest clouds with a very light layer of French Grey 20%, as well as the distant, misty hills.

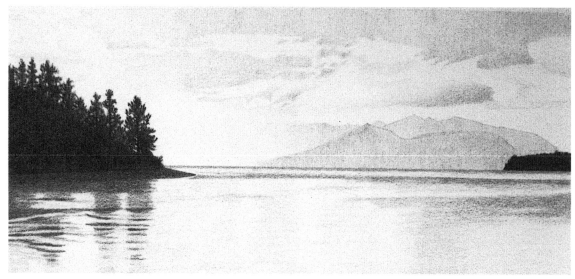

STEP 2: DARKEN THE DARKS

With a sharp point, apply Black to the trees following the shape of the branches. Use Black on the hill below the trees, as well as on the trees on the right horizon. Use a dull pencil and a ruler to add Periwinkle to the water on the horizon line. A straightedge should rarely be used in your work, but this must be straight and even or the feel of quiet, calm water could be lost. Add Periwinkle to the other ripples and darker areas except those below the trees on the left side. You want the tree reflections to carry some of the green of the trees, so with Marine Green followed by Dark Green, add reflections and ripples to the left side, using a dull point (2–4 pressure). A dull pencil works best here; some of the paper shows through if you use a dull point, which gives it a bit of texture.

Darken the clouds slightly with a very light layer of Cool Grey 50%. Use a sharp point and a smooth vertical stroke. Don't be too concerned about making these too dark, since you can always cover them with White if they need lightening later.

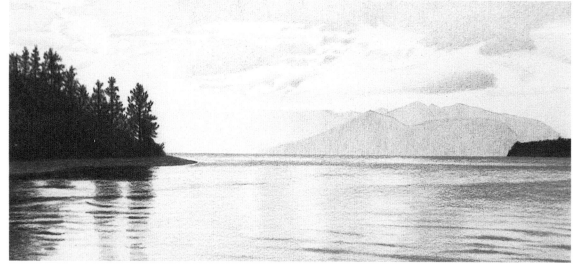

STEP 3: DARKEN THE VALUES

You want a little blue in this sky and mountains, so use Cloud Blue next, with a heavy pressure (4) on the mountain, but a very light (1–2) pressure on the clouds and sky. Next, use Cool Grey 30% over these same areas, varying your pressure (3 to 0) as the value fades out into white.

Darken the trees one more time with Black to make this area very dark and dense. Apply Cool Grey 50% in horizontal strokes using a dull point and a light to medium pressure over the Periwinkle in the water.

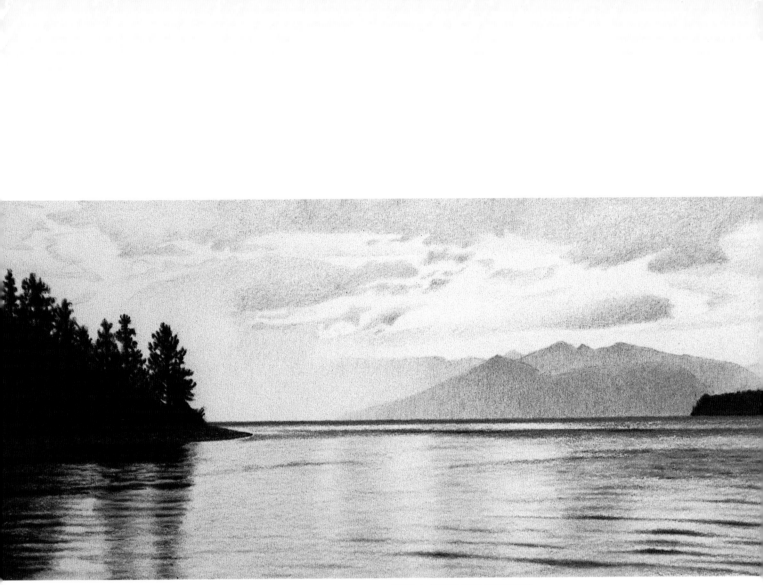

STEP 4: FINISHING TOUCHES

Darken the hills with French Grey 50%, varying your pressure from very light as they fade off to quite heavy (4) to darken and add depth to these hills.

Using a ruler, darken the horizon line with Periwinkle, then darken the other ripples, varying your pressure (2–4). With a light touch and Blue Violet Lake, cover most of the lighter water area but leave vertical gaps (sunlit reflections) as seen on the reference photo. Add French Grey 70% and 90% over the green ripple lines in the far left, followed by small touches of Yellow Ochre to warm these reflections slightly. Use a sharp Cool Grey 10% and horizontal strokes to burnish most of the water surface, especially going into the lighter tree reflections to break these up and lighten them. This last burnishing step helps give the water a smoother, shinier feel and tones down the colors a bit.

Tropics

It was a bit difficult painting this beautiful tropical ocean scene while stuck in cloudy, gloomy Seattle, Washington. If you can't be there, I suppose painting it is the next best thing! These palm trees may look a bit difficult, but they are actually quite simple. And this rich aquamarine sea couldn't be easier. The hardest part was keeping myself from daydreaming of hot sandy beaches and palm trees rustling in the breeze.

Colored Pencils

Apple Green
Aquamarine
Beige
Black
Cloud Blue
Chartreuse
Dark Green
Dark Umber
Deco Aqua
Deco Blue
Deco Yellow
French Grey 20%
Jasmine
Light Green
Limepeel
Mineral Orange
Non-Photo Blue
Olive Green
Peacock Blue
Tuscan Red
Violet Blue

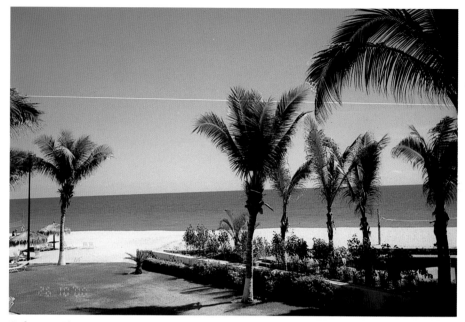

Reference Photo

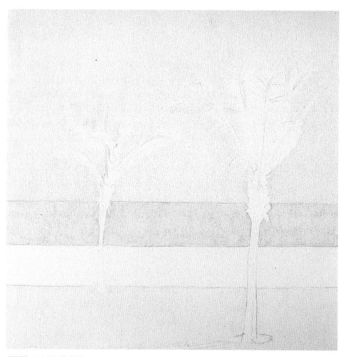

STEP 1: WASHES

Begin the sky with a very sharp Cloud Blue, using a smooth vertical line stroke and a very light touch (1 pressure). Wash the water with Deco Aqua using a very sharp, very light smooth vertical stroke. Wash the grass with a slightly dull Deco Yellow. Give the sky a second very light wash, this time with a very sharp Non-Photo Blue.

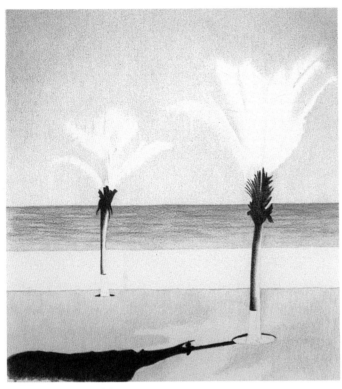

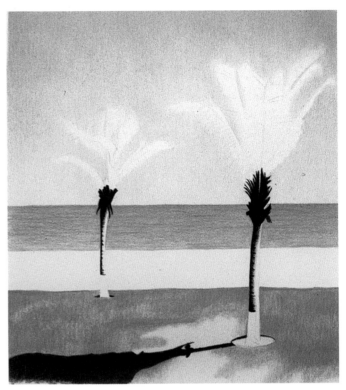

STEP 2: BUILD COLOR

You want this sky to look very smooth, so keep the point sharp and turn the pencil often as you apply two more washes of Cloud Blue followed by Deco Blue, gradually increasing your pressure to 3 in the darker areas. Notice that you are painting sky behind where the palm fronds will be. It's much easier to put the palms in front of sky than to try to work sky in between fronds later! Next, use a slightly dull pencil to apply Aquamarine in long horizontal strokes across the water, increasing your pressure slightly toward the horizon line.

Cover the grass with Chartreuse with a sharp point (2 pressure) vertical line stroke, but allow some of the earlier layers to show through. Fill in the palm tree shadow with Dark Green and Black, both applied with a sharp point (4 pressure). Fill in the palm tree trunks with Dark Umber and Black.

STEP 3: BLEND

Use a Prismacolor colorless blender pencil to smooth and burnish the sky before again applying Non-Photo Blue, increasing your pressure on the upper section. Why a blender? You need the sky to be light but at the same time densely covered. The blender fills in the valleys of the paper surface so the sky looks less airy without getting darker.

Cover the grass with Apple Green, varying your pressure (2–3), with a slightly dull point and a loose scribble stroke.

Start working on the palm tree trunks with Black. Use both a vertical line stroke and a directional horizontal stroke (4 pressure) to fill these areas up. Since you want to work back and forth between greens and blues in the water, use Light Green for another horizontal layer across the water, increasing your pressure slightly toward the back.

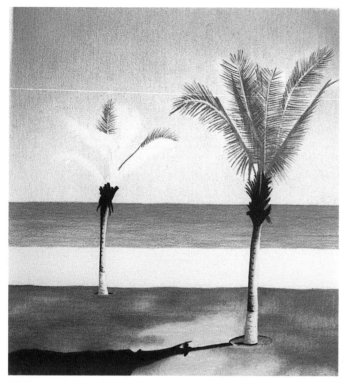

STEP 4: ADD DETAIL

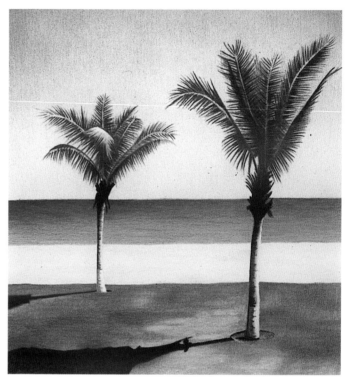

STEP 5: FINISHING TOUCHES

Wash the sand with a light vertical layer of Beige. Working horizontally, cover the grass with Olive Green, using a slightly dull point (2–4 pressure). Apply a bit of Jasmine (2 pressure) to the light side of the tree trunks.

Add Aquamarine to the water, working in horizontal strokes; vary the stroke length and pressure to suggest waves. Use a very sharp Olive Green (3 pressure) for the palm fronds. Start each stroke in the center of the frond, then sort of push out while lightening your pressure. This way, the line is relatively blunt at the beginning of the stroke but thins and feathers out at the end of each stroke. Pay careful attention to the direction the individual leaves fall.

Start this step by darkening the palm fronds. Simply go over each individual leaf again, this time with Dark Green (4–5 pressure). In areas that are especially dark, add Tuscan Red and Black. In the sunlit areas, use a mixture of Deco Yellow, Mineral Orange and Limepeel, very lightly, to add touches of color to the edges of the highlights. Use a sharp Non-Photo Blue to fill in some small areas of sky that aren't quite dark enough behind the palm fronds.

Apply Limepeel to the highlighted areas of the grass to tone those areas down a bit, then use French Grey 20% and a bit more Beige horizontally across the sand in patches with a slightly dull point.

With Peacock Blue at a sharp point (4 pressure) work horizontally across the water near the horizon line, followed by a layer of Violet Blue. Blend the water with Non-Photo Blue, using a sharp point (4-5 pressure). This lighter-value blue blends all of the previous layers together and adds density, which helps the water look like water!

Q & A

Q: Why didn't you use the Prismacolor Clear Blender Marker on the sky like you did on the Rhododendron demo (page 82)?

A: There aren't enough layers, or enough waxy buildup, to use the marker blender. The Stonehenge paper would get wet and buckle if I used the marker on this sky, which is why I chose the colorless blender pencil.

Waterfall

You might not have many occasions to paint a waterfall, but this demo can be helpful in showing you how non-white white water can be. When you make the mistake of leaving things like snow, white clothing and white water too white, you take the chance of losing depth and form. It's the darker areas of water here that really show off the "white" water!

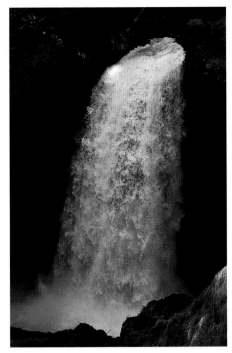

Reference Photo

Colored Pencils

Black
Cloud Blue
Dark Green
Dark Umber
Indigo Blue
Limepeel
Non-Photo Blue
Olive Green
Periwinkle
Sepia
Slate Grey
Warm Grey 70%
White
Yellow Ochre

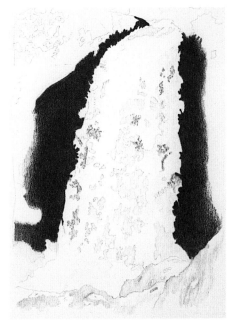

STEP 1: DARKS FIRST

Begin with Sepia using a slightly dull point and a vertical stroke (3 pressure) followed by Dark Green. Carefully outline the edges of the waterfall with both colors. Quickly scribble a little Limepeel in the foreground rocks. On the waterfall, apply Cloud Blue over all the darkest areas, using a scribble stroke (3 pressure). Over the very darkest areas, apply Periwinkle in a very short, scribbled, scattered stroke, using a fairly sharp point and a light to medium pressure.

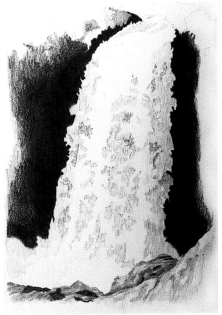

STEP 2: ADD COLOR

Intensify the dark background with a heavy coat of Black, keeping a fairly sharp point and using a vertical line stroke. This stroke creates a slightly denser, more even coat than the scribble stroke. Apply Non-Photo Blue very lightly (1–2 pressure) with a very loose scribble stroke to much of the water that is darker in value.

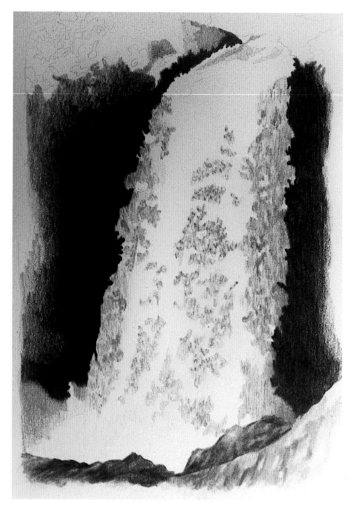

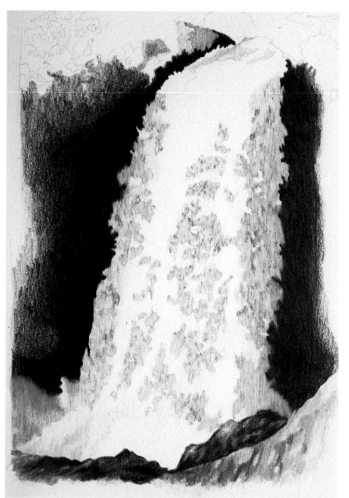

STEP 3: DULL DOWN THE COLOR

You want a blue tone for the darker water; however, the Non-Photo Blue is pretty bright, so apply Slate Grey to darken and to dull down the dark areas, varying your pressure (1–2). You will be covering these areas with White in the next step, so don't be too concerned about getting them too dark because the White will lighten them considerably. Very loosely apply Yellow Ochre, Olive Green, Dark Umber and a little Black to the foreground rocks in a directional scribble to quickly lay in these rocks.

STEP 4: BURNISH

In this stage, take a dull White pencil and burnish (5 pressure) over all the darker areas of the water, using a large oval stroke to sort of push the underlayers together. Also burnish into the dark outer edges a bit to blur the line between waterfall and background.

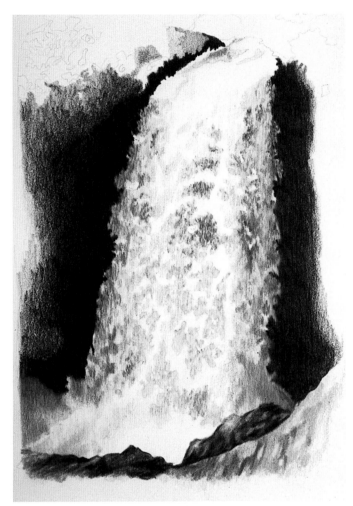

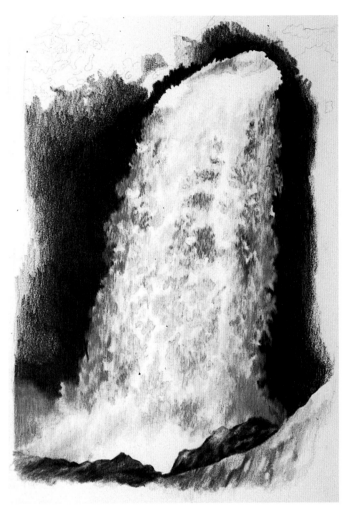

STEP 5: DARKEN AND DEFINE

The darkest areas of water still need quite a bit of definition, so using a slightly dull point, loosely scribble in value and detail with Indigo Blue and Warm Grey 70%. With a very dull point, lightly scribble over the top of much of the darker areas. Use a dull point here to purposely skip over much of the paper surface to give an uneven, mottled look.

STEP 6: FINAL BURNISH

Burnish over almost the entire surface of the waterfall except the very lightest whites using Cloud Blue with a slightly dull point. Use a rather large, loopy scribble stroke for this layer to define some of the larger shapes in the cascading water. Burnish over almost all the areas one more time with White, softening the edges and softening the values and color.

Barn Doors~Old Wood

Wood grain is really a lot of fun because it's one of those textures that looks hard to paint while really being quite easy. Believable wood can be accomplished by getting the colors right and by adding wood grain lines that are varied in length and width. Making wood grain lines too uniform is the only thing you really have to watch out for. When drawing the grain, use your reference photo as a jumping off point, but don't feel you have to follow each and every line. You'll go crazy! Just get the feel of the pattern of the grain, and go from there.

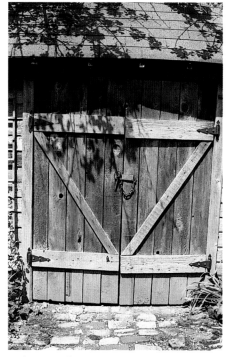

Reference Photo

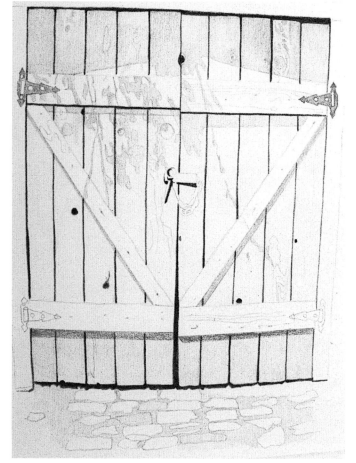

STEP 1: WASHES AND DEFINING DARKS

Begin the barn doors by laying in the darkest darks with Dark Umber, using a sharp point (3–4 pressure). Because these darkest areas are mostly narrow, horizontal spaces, use a directional, horizontal stroke because there is not quite enough room for a vertical stroke. Wash all vertical boards with Beige using a sharp pencil and a vertical line stroke (1 pressure). The shadowed areas receive a Goldenrod wash with the same pressure, point and line. Using a scribble stroke to add a bit of texture, cover the lower boards and a few of the upper boards with Slate Grey, still using a very light pressure. The hinges get a coat of Slate Grey with a fairly heavy pressure (3). Use a very sharp point for these; because the area is so small, you need to work meticulously.

Colored Pencils

Beige
Black
Cool Grey 50%
Dark Umber
Goldenrod
French Grey 20%
French Grey 30%
French Grey 70%
Light Umber
Mineral Orange
Sienna Brown
Sepia
Slate Grey
Yellow Ochre

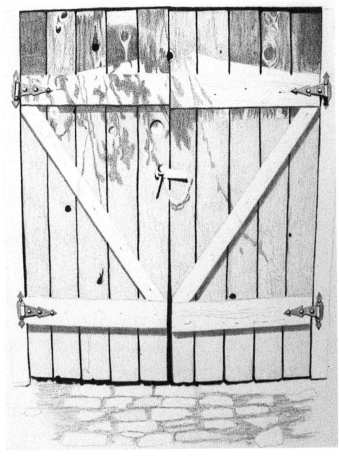

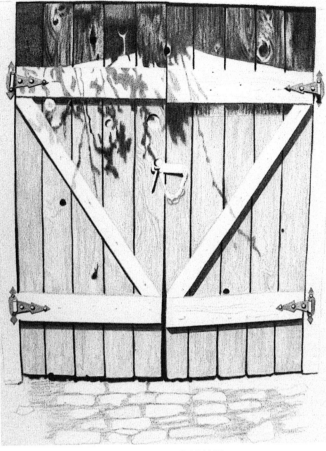

STEP 2: SHADOWS

Your first step is to complete the darkest areas with Black, using a sharp point (4 pressure) so you can get into all the valleys of the paper tooth. With your darks established, move on to the upper shadowed portion with a layer of Sienna Brown, varying the pressure (2–4) depending on the intensity of color and value of each board. Rather than using a strict vertical line on these boards, start suggesting the wood grain by increasing and decreasing your pressure with directional lines. Use Slate Grey at a fairly heavy pressure (3–4) for the two bluish boards and the shadows that fall across the top horizontal board.

The main horizontal boards need to be slightly dull so they look old and weathered and so the yellow layers you'll add in the following steps don't become too bright. A wash of French Grey 30% (1.5 pressure) with a slightly dull point add a bit of texture and keeps the boards from becoming too bright later on in the painting process.

STEP 3: FINISH SHADOWS AND BUILD VALUE

As scary as it is, you need to finish the upper shadows first, so with Cool Grey 50%, and Sepia, darken these shadowed boards using a slightly dull pencil and varying pressures (2–4). Use Yellow Ochre, varying your pressure (2–4) over the horizontal boards in the middle section. You will actually do this in two steps. First give the boards an all over light wash with a slightly dull point (2–3 pressure). Add some wood grain with a sharp point (2–4 pressure).

Use Sepia (3–4 pressure) to cover the shadows that fall across the middle section, because Sepia is a dark brown that is quite dull, which is perfect for shadows. (Although Dark Umber is a bit darker in value than Sepia, it has more richness and is a bit brighter.) Use French Grey 20% on the lower boards, varying your pressure here and there to add some texture.

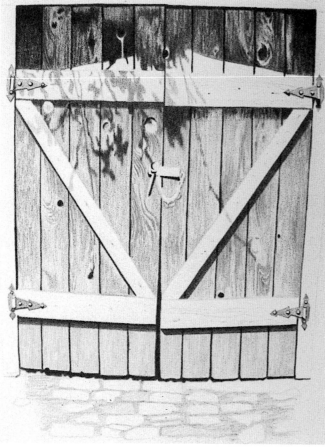 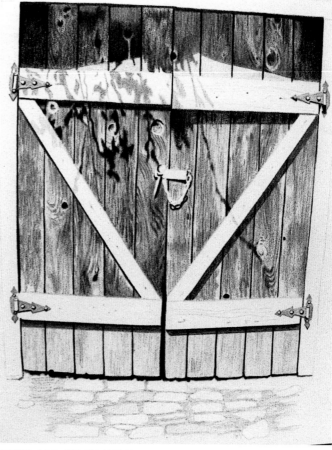

STEP 4: MIDTONES

Begin work on the middle section using Mineral Orange and Goldenrod to start adding grain and color to the boards. Allow some of the under layers to show through. Remember, it's not necessary to follow your reference photo perfectly for the wood grain. Just notice the direction, length and width of the grain, and wing it. Use Sepia with a sharp point (2–4 pressure) for the shadows that fall across this section.

STEP 5: ADD COLOR AND TEXTURE

The upper shadowed boards look a little too dull, so use Sienna Brown and Slate Grey (3–4 pressure) to liven up these boards. To build the color and wood grain of the middle section, get a handful of pencils to keep in your left hand: Sienna Brown, Light Umber, Sepia and French Grey 70%. Moving back and forth with this handful of colors, build the color and grain of the mid-section, using a full pressure range (1–5) and both sharp and dull points. Some of the wood grain needs a sharp point because it's relatively fine, while other areas need a duller point, because the grain becomes thicker. Add a wash of French Grey 20% as a base for the highlighted boards just below the upper shadow, which you've left white up to this point.

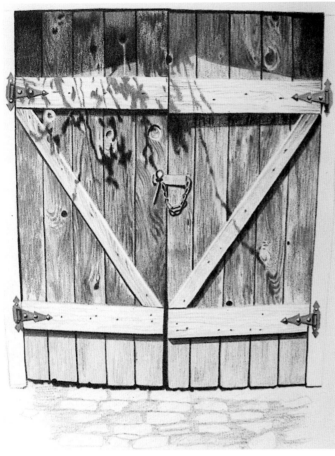

STEP 6: FINISHING TOUCHES

Use Cool Grey 50% followed by Slate Grey with a sharp point to finish up the hinges, then add depth to the diagonal boards by using touches of Light Umber and French Grey 20% in a linear, grain-like stroke. Leave the narrow upper strip of both of these boards as pure paper to help give the boards a three-dimensional quality. A few suggestions of wood grain with a French Grey 20% across the horizontal boards finish up these weathered, colorful, fun-to-do barn doors!

New Wood

Here is a sample of new wood. The process is exactly the same as with the barn doors; just the colors are different. After washes of Jasmine and Pink Rose over the entire wood area, I drew in the wood grain with Mineral Orange then Goldenrod. I built the shadowed areas with Rosy Beige to dull it slightly, then Goldenrod and Light Umber, using a slightly dull point to build texture. I then darkened the grain again with Henna, then Dark Brown only on the grain that is in shadow. You want to soften these grain lines by using a lighter pressure on either side. In other words, the center of the grain line may be a 3 pressure, but the outer edges will become a 2 pressure and then a 1 pressure so they blend into the wood. I added a light coat of Peach to the wood that is highlighted.

Stone Stairs

I've always enjoyed painting stone like that found in this demo because I love watching it begin to look chiseled and cracked as I add a layer here and a line there. If you're attempting to render grey stone, remember that virtually nothing in nature is just grey alone. Add color—either cool or warm, or both—to enliven stone and to make it look more realistic. You will, however, want to use colors that are slightly grey. In other words, Periwinkle is a better choice than True Blue, which has no grey undertones. Clay Rose is a better choice than Pink for the same reason.

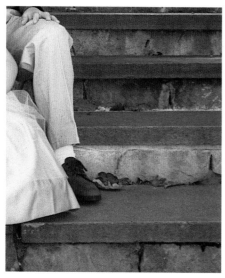

Reference Photo

STEP 1: WASHES OF COLOR

Begin the stairs with a wash of Beige (2 pressure) with a slightly dull point using a scribble stroke. Use a slightly dull point and a loose scribble stroke throughout this demo to add texture and allow under layers to slightly show through. Start modeling with Goldenrod; start creating form and depth by increasing and decreasing your pressure and by leaving some areas uncovered with this layer. Next, model with Mineral Orange (only the bottom two stairs are shown covered here).

With the washes finished, draw in the cracks with Cool Grey 70%, followed by Black. It's a little scary making these so dark at this point, but getting them dark enough from the beginning will help get the rest of the values correct. Wash the step fronts with Warm Grey 30%, followed by French Grey 50% (3 pressure). On the steps themselves, layer Blue Slate (1–2 pressure).

Colored Pencils

Beige
Black
Blue Slate
Clay Rose
Cool Grey 70%
Dark Umber
Goldenrod
French Grey 50%
French Grey 70%
French Grey 90%
Mineral Orange
Periwinkle
Warm Grey 30%

STEP 2: DULL DOWN THE COLORS

Now it's time to dull down all those colors used in the first step. This is easily accomplished on the stone with loose layers of Clay Rose and French Grey 50% (2 pressure). Leave some areas covered, but also cover some areas that were left quite light in the previous step. This technique creates many gradations of color and value with only five colors. Tone down the steps with French Grey 70%, varying your pressure, but applying with a smoother stroke than the stones.

STEP 3: DETAILS AND FINISHING TOUCHES

Place the hard shadows under each step with Dark Umber then Black (4 pressure). Differentiate the step fronts and the steps themselves by scribbling more French Grey 70%, then French Grey 90% on the step fronts. Use the French Grey 90% to create a rough, bumpy line along the top of each step front to create the look of rough stone. Layer Periwinkle on the steps (2–3 pressure). Leave a very thin, light area toward the front of each step to create a three-dimensional quality. Use French Grey 70% loosely over the stones to create shapes, lines and texture.

Stones or Pebbles

These rocks nearly drew themselves—a few bright washes followed by some dulling down with cool and warm greys, and that's about all there is to it! The only thing I really had to be careful about was to keep my first layers light, so I could add plenty of layers without the danger of burnishing. If I end up having to burnish them, they may end up looking like polished rocks, which is not the look I am going for. I'd prefer a softer approach so the rocks look slightly rough and textured rather than smooth.

Colored Pencils

Beige
Black
Blush Pink
Cool Grey 30%
Cool Grey 50%
Cool Grey 70%
Cream
French Grey 10%
French Grey 20%
French Grey 30%
French Grey 50%
French Grey 70%
French Grey 90%
Goldenrod
Indigo Blue
Jasmine
Light Umber
Peach
Peacock Blue
Sepia
Slate Grey
Yellow Ochre

Reference Photo

STEP 1: ROAD-MAPPING

Start these stones by defining the darks with a sharp French Grey 90% (4 pressure) but softening the edges of some of the shadows by decreasing the pressure. Wash the warm rocks with a light coat of Jasmine, the cool rocks with Slate Grey, the pinkish rocks with Peach and the grey ones with French Grey 20%. Leave the lightest rocks uncovered for now. Use the smooth vertical line stroke and start these washes with a very light touch because you want to be sure you have plenty of tooth to add many layers of color without having to burnish them.

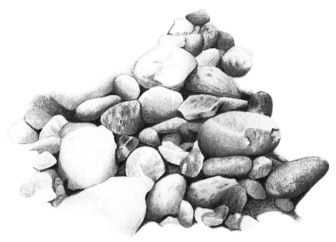

STEP 2: ADD BRIGHTS

It is almost always preferable to start with bright colors and tone them down, rather than start with dull colors and try to brighten them up. Choose some relatively vivid hues to build the color on these rocks. Over the warm rocks, use Yellow Ochre, Goldenrod and touches of Peach. The cool stones are layered with Peacock Blue. Vary your pressure (1–2). Use Blush Pink on the pinker stones and add a bit of color to the grey stones with Slate Grey.

STEP 3: DULL DOWN THE COLOR

With the color of the stones built up somewhat, the shadows are now not dark enough. With a sharp Indigo Blue and Black, deepen the shadows (4 pressure). Be careful, however, to soften your touch as you come out of the deepest shadows. Now start paying a little more attention to the detail in the reference photo and start using greys to add detail and tone down the stones. Use an assortment of greys for this step, both Cool and French Greys ranging from 30% to 70%. Use some Light Umber and Sepia on the warmer rocks and Cream, Beige and French Grey 10% on the lightest rocks.

STEP 4: FINISHING TOUCHES

Continue to tone down and darken the stones with French Greys 50% and 70%. Finish modeling by bringing up the shadows a little higher on each individual stone. Use a dull point with all colors added in this step to add texture and give them a slightly rough look.

Old Brick

Want to know what my two favorite things to draw are? Denim jeans and old brick! Jeans are fun because it takes just a few dark puckers and the right combination of colors—they almost draw themselves. Old brick is fun because with a few shadows and the right color combinations, you've got old brick and it all goes very quickly, as you'll see.

Colored Pencils

Black
Celadon Green
Dark Umber
French Grey 30%
French Grey 70%
French Grey 50%
French Grey 90%
Mineral Orange
Peach
Pink Rose
Pumpkin Orange
Sepia
Sienna Brown
Terra Cotta

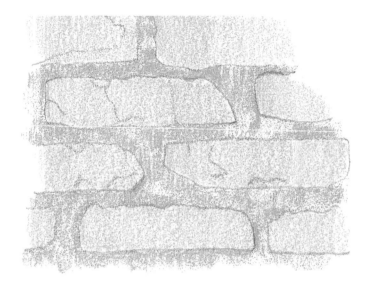

STEP 1: WASHES

Lay in light washes by starting with Celadon Green (2 pressure) with a slightly dull point for the mortar, immediately followed by a loose coat of French Grey 30% (2 pressure). Don't cover the Celadon layer completely but let some areas peek through. (Why Celadon Green as a first layer? I don't like to use greys without some color under or over them; the same way I won't use Black without also adding some other color. Greys and Black, without some other hue, tend to be very dull and lifeless. Celadon Green is a grey-green, so it seems a good choice here.) Wash the brick with a light coat of Pink Rose, which is a grey-pink, followed by a second wash of Peach, using a smooth vertical line stroke.

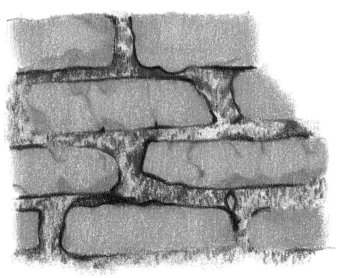

STEP 2: SHADOWS AND COLOR

Apply a medium layer of Mineral Orange on the bricks, again using a smooth stroke. Over the cracks and imperfections, add a bit of Sienna Brown so you don't lose these lines as you build the color on the bricks. Use a sharp Black for the hard shadows around the brick and a few of the cracks in the mortar. With short scribble strokes, build texture in the mortar with French Grey 70%.

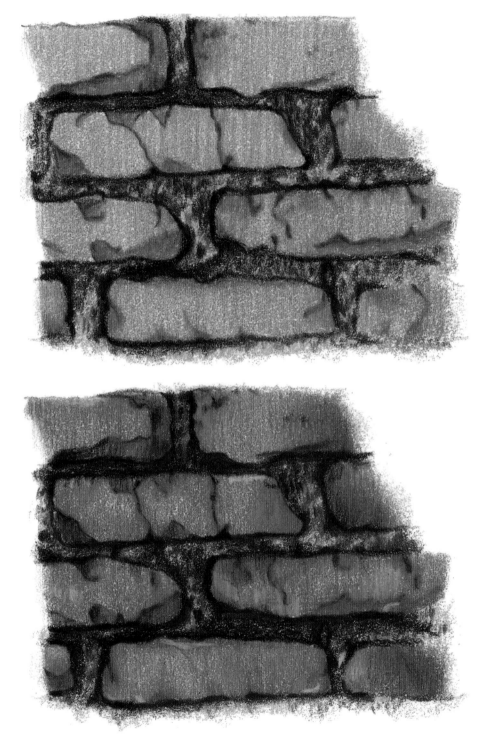

STEP 3: ESTABLISH DARKS

To avoid getting too dull, again cover the mortar with a dull Celadon Green (3 pressure) followed by Dark Umber in only the darkest areas. Cover the bricks with Pumpkin Orange, using a vertical line stroke (3 pressure) and a slightly dull point, so some of the underlayers show through. Use Sepia (which is a very dull brown, so it works well for shadow areas) on the cracks in the brick. You want these cracks to be dark, but don't darken them during the last step. It is better to darken them first, then add another layer or two on top to blend in the details. If you put cracks (or wrinkles/freckles) in on the last layer, they often look drawn on instead of blended in.

STEP 4: FINISHING TOUCHES

Finish the mortar with a dull French Grey 90%, softening the edges of the harder shadows. Use Terra Cotta and Sienna Brown for the last layers of the bricks, varying your pressure (3–4) and leaving a few areas uncovered. The final touch is to use a bit of French Grey 50% here and there to age the bricks.

New Brick

Looks like I've saved the very easiest demo for last! You don't really even need drawing skills to paint new brick. Some rectangles with the right color combinations and a consistent shadow line are all it takes.

Colored Pencils

Beige
Cloud Blue
Cool Grey 70%
Deco Blue
French Grey 20%
French Grey 70%
Goldenrod
Indigo Blue
Light Umber
Mineral Orange
Pink Rose
Rosy Beige
Sepia
Sienna Brown
Terra Cotta

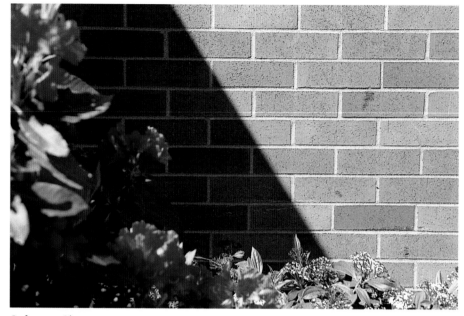

Reference Photo

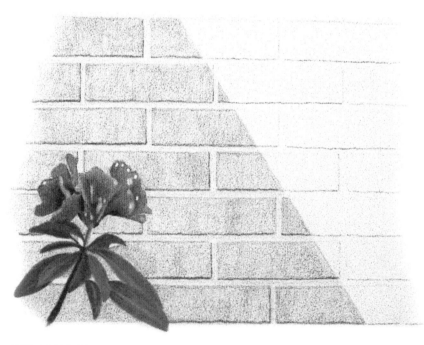

STEP 1: WASHES

Begin these bricks by putting in the shadow with French Grey 70%, using a sharp point. Use a 3 pressure on the dark side, 1 pressure on the light side. Don't use a straightedge for these; using a ruler to get very straight lines will make this look like an architectural rendering. Also, the only real texture in these bricks is in the edges, which you can accentuate by making the shadow lines slightly bumpy and irregular. Wash the bricks with a vertical line stroke (1.5 pressure) and a sharp point using Beige on the light side and Sienna Brown on the shadowed side.

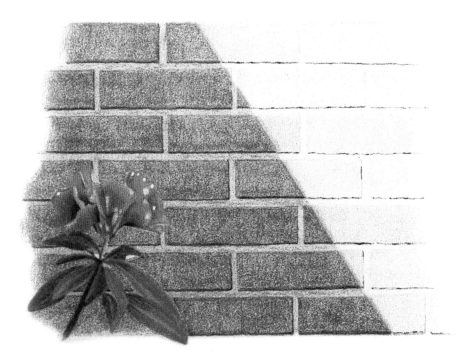

STEP 2: VARY THE COLOR

Look at the reference photo—these bricks are a mix of oranges, pinks and greys. Orange has already been represented in the first step, so apply Pink Rose to both sides, using a 1 pressure on the light side and a 2 pressure on the dark side. You want to get the shadowed side darker first, so use Terra Cotta as a wash (3 pressure) using a vertical line stroke. Reinforce the shadow on this side with Indigo Blue (3 pressure) using a very sharp point.

On the light side, very lightly and carefully wash Mineral Orange (0.5 pressure) on a few of the bricks, followed by a wash of Pink Rose over a couple of them (1.5 pressure).

Look carefully at the reference photo; you'll see that immediately to the right of the diagonal shadow line there is a thin area running along this shadow that is brighter. Carefully run a little Mineral Orange on the right side of this shadow, except in the mortar where Cloud Blue is used.

STEP 3: FINISHING TOUCHES

The bricks are looking a little bright, so dull down the shadowed side with Light Umber (3 pressure). Layer Sienna Brown (4 pressure) on all of the bricks and cover some bricks in the shadow side with Sepia so there is some variation in color and value. On the mortar, use Cool Grey 70%.

The lighter bricks need to be dulled a bit, so use French Grey 20% very lightly (1 pressure) over this entire side. Use Rosy Beige on two of the bricks, Mineral Orange on two others and Goldenrod on two more, all with a sharp point and a very light touch. Use Mineral Orange, along the right side of the shadow, except in the mortar, where Deco Blue is used.

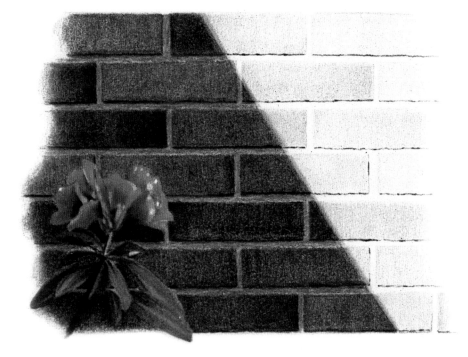

Frequently Asked Questions

Q: When do you use the burnishing technique in your paintings?

A: I don't burnish very often, only when I need to create a shiny, hard surface like metal or glass. I never hesitate to burnish or add lighter colors on top of darker burnished areas.

Q: Where is the best place to keep your pencils while you are drawing?

A: My pencils are in three rectangular, plastic boxes: Skin tones in one box; greys, blues, and grey-like colors (liked Greyed Lavender) are in the second box; and everything else in a third box. These stay on my angled drawing table with the help of a piece of non-skid rubber shelf liner.

Q: Do you ever take pictures on overcast days? Or does the lack of shadow make your paintings look one-dimensional?

A: Living in the Northwest United States, I really have no choice but to take pictures on overcast days, believe me! I much prefer sunny days, but I travel often and have to plan my photo shoots ahead of time, so I often have to take what I can get. When I'm working with a reference photo taken on a cloudy day, I tend to increase the light by lightening highlights in the painting and darkening shadows slightly so it looks like there was more light than there really was. I do this unconsciously; I like lots of contrast and drama, so if it's missing in the photo, I add it!

Q: I am working on a very large portrait commission, 30" x 40" (76cm x 102cm) on heavy illustration board. I have a large drawing table and I have to lean over the drawing to work on it. This makes my back hurt! Do you work vertically on larger drawings or on a slant?

A: My drawing table is always on a slant, and if it's a large piece, the slant is even greater; but I often have to stand to work on the top of a large piece, so I lean on my left elbow. I really don't like working on really large, vertical pieces for that reason. I have thought that if I ever have a very large vertical piece, I'd work vertically by attaching a large piece of smooth mat board to a wall and then attach my paper to the mat board.

Q: How do you maintain your portfolio? Do you have a slide portfolio? Is your work professionally photographed or do you photograph your own? If a client wants to see some of your work, what do you show them?

A: I'm not sure I ever actually had a true portfolio of my work. I have never been that organized! My best recommendation for maintaining a portfolio would be to have slides taken professionally. Then print six to ten of your best slides in an 8" x 10" (20cm x 25cm) format. Place these in a professional looking, high-quality portfolio along with the reference photos you used in creating those images. Add a biography and if possible, include a testimonial or two from a satisfied client.

Q: On page 116 of your book Colored Pencil Portraits Step by Step, there is a reference photo of two children. The photo depicts the children's faces much darker (light wise) than your rendition does. My question is, how do you determine how much to deviate from the photo?

A: This is a very difficult question to answer—how do I know? I use my value viewer (see page 18) constantly, but I almost never go as dark as the photo. I use the value viewer to show me contrast, color and value but not to determine exactly what degree of value to go to. I guess this is where my own style or interpretation comes in. But once I've established a dark on my painting, I use that to determine the value of the rest of my portrait.

For instance, let's say an area in my photo is a 10 value and the area next to it is a 5—half the value of the dark area. In my painting I might have only given that dark area an 8 value, but then my area next to that would be a 4, so my values stay consistent with the photo but are not identical.

Q: Could you offer some special tips on modeling light-colored objects, especially yellow ones—lemons, peaches and such—when using an underpainting. I find the Indigo-Tuscan Red undercolor doesn't work too well with these objects.

A: Probably the two best known proponents of underpainting are Bernard Poulin and Morell Wise. Wise's Colored Pencils, from the The Artist's Library Series, was one of the earliest books published on colored pencil, and if you haven't seen it, it's a little gem. I never underpaint. People think I'm patient because I can spend so long on

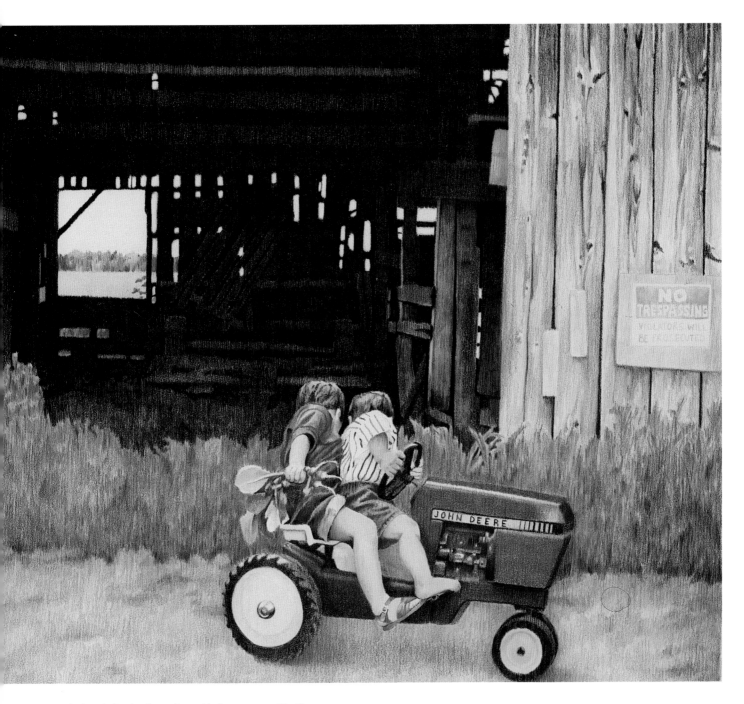

a single painting, but I'm really not. Under-painting for me is a step I don't have the patience for! But if you want to try it, I'd really recommend Wise's little paperback. I would start something light (like lemons or peaches) with washes of Cream or Deco Yellow, or both, without an underpainting.

Flat Tire
17" x 20" (43cm x 51cm)
Private Collection

Q: I am getting ready to mat several finished colored pencil drawings and am curious about how you approach this issue, since I know you sell all your paintings framed. Do you stick with neutral mat colors or coordinate with the colors in the portrait? Do you approve mat colors with the client?

A: I always mat in white, or at least shades of white. It may be a creamy white, greyish white, etc., but it's always white. In my opinion, nothing shows off the work like a white mat. The goal of framing is not to show off the framing but to focus attention on the work. The mat, in a way, is like a giant value viewer isolating the work so you can really focus on it.

I don't approve mat colors with the client; no one's ever asked or commented about a mat. I'll take that as a good sign! In my humble opinion, if the mat or frame is commented on too much, it's a sign that the artwork is being upstaged by fancy framing.

Q: I had a question about how you got your first commissioned work. I heard that you initially had your work shown in galleries. Wouldn't a gallery normally be protective of their artists, wanting exclusive rights to their creations?

A: Well, it's not quite that rigid, usually. It's true that galleries will often ask for exclusive rights to show in a particular area. In other words, I would expect to hang my original work in only one gallery in the greater Seattle/Tacoma area. But I've never had a gallery ask for exclusive rights to all of my work! And if someone had ever asked, I'd have turned them down flat, unless they could somehow guarantee me a certain income by that sort of exclusive contract.

On the other hand, galleries typically don't want to show a portrait artist's work since portrait work is entirely commission-based. I did talk two different galleries into showing my work, and keeping a portfolio for me, with an agreement to pay twenty-percent of the portrait fee to the gallery. I received only two direct commissions from that exposure, but then received an additional six word-of-mouth commissions from those original two clients.

Also, my first commission did come to me through a gallery, but indirectly. A woman saw my work in a gallery, took down my name and number, then called me two years later! I wasn't even represented any longer by the gallery when the painting was commissioned.

Q: How do you keep your work clean? I've noticed that you sometimes work from the outside to the inside when painting. Do you mask parts of your drawing or just use a piece of paper to cover what you're not working on?

A: I don't cover my paper at all when working, yet I don't seem to get my paper very dirty. This has puzzled me, but after seeing others work at workshops, I'm pretty convinced that I'm able to keep my surface clean because I brush constantly! By brushing often, I keep any dust and grime off the paper so there's not much to grind into the clean areas. Also, some papers pick up more pencil grime than others. Stonehenge is a particularly dirt-resistant paper.

Q: I am currently on my second Boston electric pencil sharpener. I have broken off the tip of my pencil twice, ruining the pencil sharpener's use. Is there some sort of trick to getting the tip out if it breaks off in the sharpener?

A: The trick is muscle-power and a graphite pencil! Use a regular pencil and push really hard. Eventually the tip will go through the sharpener and you're good to go. It's not a bad idea to sharpen a graphite pencil now and then, anyway—it keeps the blades sharper.

Q: Why do you frame your artwork instead of just matting it? Do you frame them yourself? That can be pretty expensive and eat up your profit.

A: Glass makes such a huge difference. After all these years, I'm still amazed at how much more important a piece looks as soon as it's in a frame and behind glass. My portrait prices are so high, that I feel the $100 to $150 it costs me is well worth the presentation value of a framed piece. I want my client to be able to hang it right away, while she's excited about the portrait. Finally, it's much easier for a client to ask for changes when the drawing is unframed. There's no glass barrier between her and the painting, so she feels freer to ask for changes. A framed piece looks *finished*, and less likely to elicit a change request. That alone is worth $100!

Q: When a client commissions you to do a portrait, do they own the copyright? Can they have copies made of your artwork?

A: No, the client does not own the copyright. You own it, unless they buy the rights from you. As a courtesy, I ask my clients for permission before copying their portraits. I prefer to honor the privacy of my clients because most of my subjects are children. In all my years of printing, I've had only one client ask that her child's portrait not be reproduced. But it is fully within my rights to reproduce any image I have created. Your client needs to ask you for permission to reproduce your painting.

Q: What do you use to seal your work? The pictures I do not seal or immediately mount and frame become smeared and spotted regardless of the protective cover used.

A: I don't actually seal my work. I apply two light coats of Krylon Workable Matte Fixative when the portrait is complete to keep any wax bloom at bay. Wax bloom is a thin film of wax that rises on your paper surface over time. It's especially noticeable in dark areas where there are many layers or in areas that have been burnished. I frame my work immediately after completion.

The Curtsy
9" x 6" (23cm x 15cm)
Private Collection

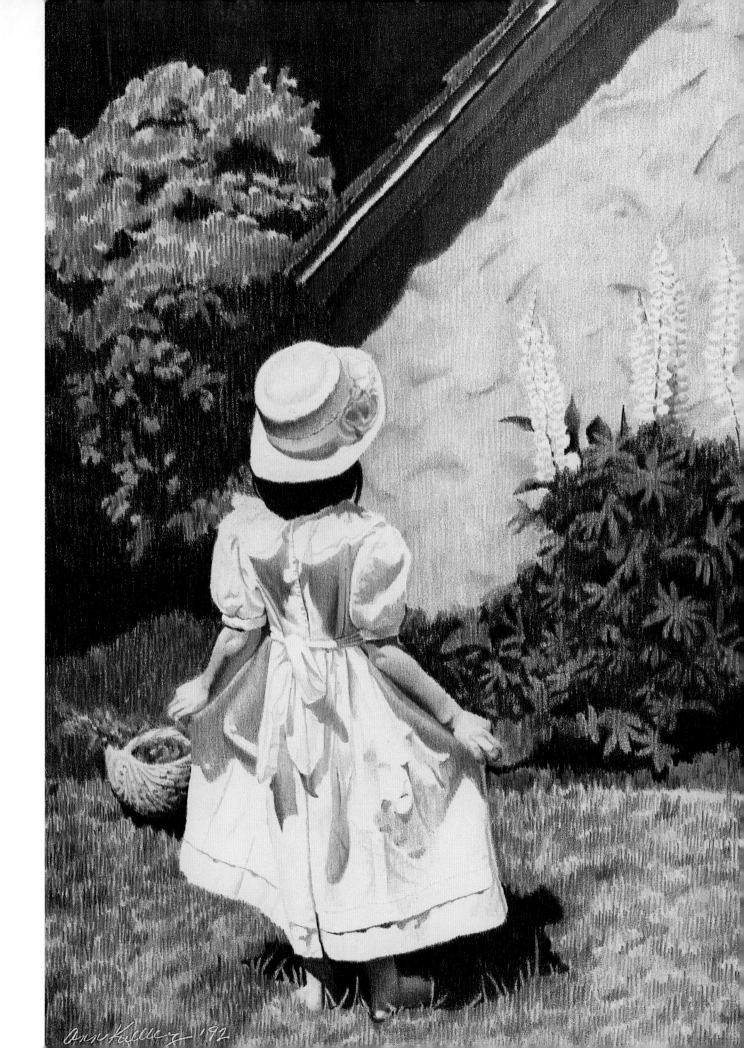

Q: A friend of mine is an excellent oil painter. She was doing commissioned portraits for awhile. When I told her about my interest in doing the same with colored pencils, she warned me against it. It had been her experience that people want a fantasy image of themselves, not the truth. She maintains that clients just don't see themselves the way they are. Are some clients really so aggravating? If so, how do you handle clients like these?

A: Painting commissioned portraits requires you to be both an artist and a psychologist. One of the reasons portraits are so expensive is that only a small percentage of artists can really capture a likeness. And of that small number, only a few can take working with people! There's just a whole lot of people skills, salesmanship, and psychology that is required. Here are a few tips:

1. Act like an expert. That doesn't mean have an attitude, and I'm not talking about acting professional, although that doesn't hurt. Approach a commission with confidence; prepare answers to questions they might have, have a plan and procedure outlined, and maintain a friendly, easy attitude like you've been doing this for years and know exactly what you're doing.

2. Act like you don't need the commission. This is a hard one, but people can smell desperation and they don't like it! No matter how badly you need or want a commission, somehow you've got to act as if you don't! If you seem desperate, the client automatically has the upper hand. If they have the upper hand, they can easily exercise that power by way of pickiness and dissatisfaction.

3. Let them know what they're getting. Make sure they've seen a fair representation of what they can expect to receive. In other words, they should see several examples of your work before you begin their portrait, so they know what your skill level is, and what you're able to do and what you're not able to do.

4. Make changes only after a waiting period. If your client wants you to make some changes to the portrait, ask that they wait a few weeks. In fact, make sure they understand this from the start. Often, by the time their friends have seen the portrait and oohed and aaahhhed over it, they're happier than when you first delivered it, and might decide it's just fine as it is.

Q: How do you determine the various colors and the sequence of those colors used when you're doing the layering of colors? Is it just experience and your artistic eye? Or is there a recipe that others can learn?

A: I would definitely say that it is not a recipe, at least not for me. I do have a technique to find the right combination of colors. (What's right? To me, it's just what's pleasing. But what's far more important than the right color is the right value!) My secret is the value viewer. Nothing helps me more to determine color. I place the viewer on my reference photo over the section I'm working on and ask myself a series of questions. Let's say the area is a part of a blue sweater. While looking at the isolated area through the viewer, I might ask myself if the blue is on the green side (warm) or the purple side (cool). If it's cool, I might ask if the purpleness of it is a bright purple, like Lilac, or a dull purple, like Greyed Lavender. If I can't tell, I grab pencils I think are close, then hold the point of those pencils up to the isolated circle in the viewer to find a close match. I also ask myself how dark the isolated area is. Is it as light as Cloud Blue, or as Dark as Indigo Blue? Once I've figured out the main color (say it's Blue Slate) I then ask if I see any other color. Is it a greyish Blue Slate? Is so, which grey?

What's the best thing about working with colored pencils? If you use a light enough touch, you can keep adding layers until you get the color you want! I may go back to the value viewer five or six times, adding color each time, before I'm satisfied.

Q: Is there a right or wrong side to Stonehenge paper? I have found that one side is a little bit smoother than the other. Which side do you prefer to use?

A: Depending on the piece of paper you happen to purchase, the two sides of Stonehenge can either be very similar or quite different. If it's hard to tell the difference, run your palm very lightly over the surface. If you feel a little pull, or a felt-like surface, that's the rougher side. I prefer to use the smooth side.

Kathleen
8" x 10" (20cm x 25cm)
Private Collection

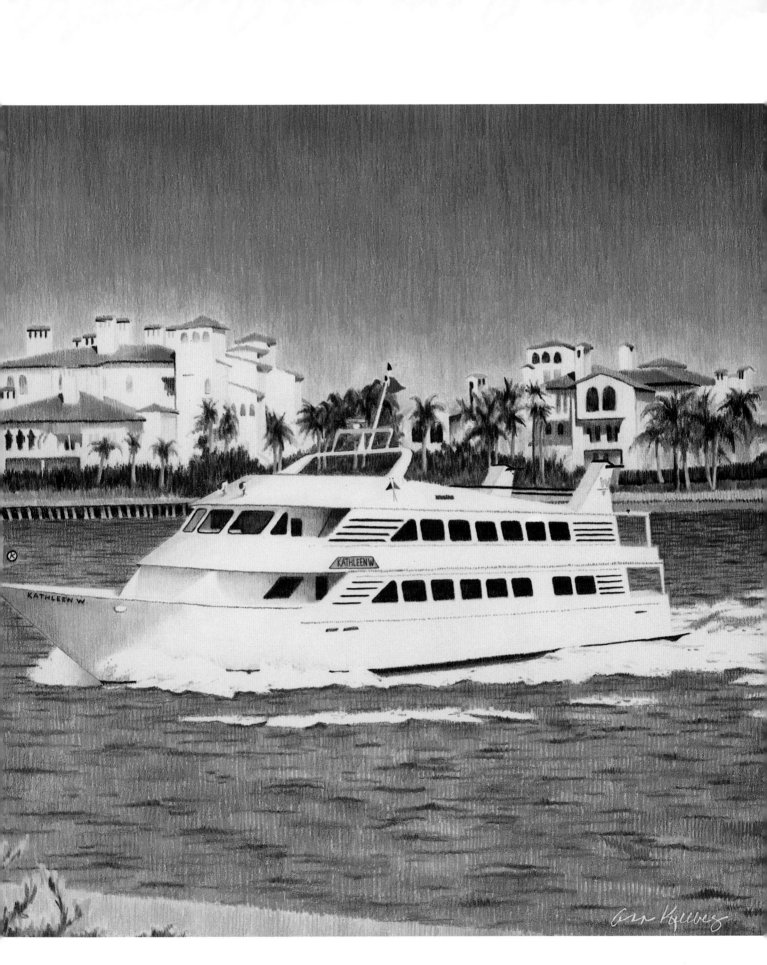

Index